IMAGES
of America

LINCOLN PARK

CHICAGO

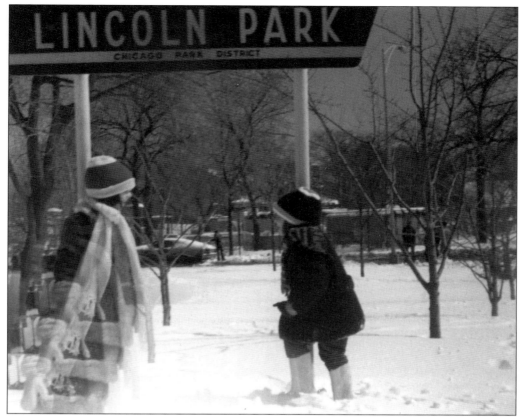

Young sisters Melanie and Mindy Apel take a walk following a snowfall in the winter of 1975. The entrance to the playground on Dickens Avenue between Lincoln Park West and Stockton Drive, just across the street from the Lincoln Park Zoo, is marked with this standard Chicago Park District sign. (Photo courtesy of Apel Family Collection.)

Cover Photo: This photo was taken in the late 1800s inside Miller's Pharmacy, which is now Braun Drugs, the oldest pharmacy in Lincoln Park. The identity of these children is unknown, although they are believed by some to have been ancestors of the Spooner family who lived in Lincoln Park until the early 1990s, when the surviving generation took off for other parts of the country. (Photo courtesy of Braun Drugs/Mrs. Norman Barry.)

IMAGES
of America

LINCOLN PARK

CHICAGO

Melanie Ann Apel

In association with the Chicago Historical Society
and with Mindy S. Apel

ARCADIA

First Printed 2002.
Reprinted 2003.

Published by Arcadia Publishing,
an imprint of Tempus Publishing, Inc.
Charleston SC, Chicago, Portsmouth NH,
San Francisco

Printed in Great Britain.

Library of Congress Catalog Card Number: 2002108560

For all general information contact Arcadia Publishing at:
Telephone 843-853-2070
Fax 843-853-0044
E-Mail sales@arcadiapublishing.com
For customer service and orders:
Toll-Free 1-888-313-2665

Visit us on the internet at http://www.arcadiapublishing.com

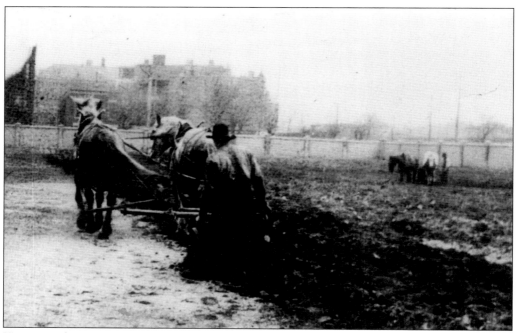

Known in the 1870s as "Father Smith's Farm," a five-acre plot of land became home to the first DePaul University campus. The land was named after the Vincentian priest who founded St. Vincent's parish. (Photo courtesy of DePaul University Archives.)

CONTENTS

ACKNOWLEDGMENTS

It is not without an amazing number of contributions of both photographs and information that this book came together. There are so many people to whom I owe sincere thanks, most of whose names appear throughout the pages of this book. In addition to those whose names appear beneath their photos, I wish to thank Kathryn DeGraff and Joan Mitchanis at The DePaul University Department of Special Collections; Steven Sullivan and Dr. Paul Heltne of the Chicago Academy of Sciences/Peggy Notebaert Nature Museum; Mrs. Nancy Stocking of Lincoln School; Andrew Kaplan of Francis W. Parker School; Felicia Dechter of *Skyline* newspaper, Kim Klausmeier at the Lincoln Park Chamber of Commerce; Alderman Vi Daley, and so many others who in passing helped me accomplish publishing this book. Special thanks go to those individuals who spent time helping me, for no other reason than because I asked them to. They helped with such an enthusiasm, it felt almost as if we were authoring this book together. They are Joan Fischer Stowell, Marj Barry, Ken Little, and Barry Smith. I especially wish to thank Colleen Henry for her hard work and dedication to this project.

Although many of my sources were people I have known for years, having grown up alongside them in the Lincoln Park neighborhood, working on this book reminded that there are also still good people out there willing to help a virtual stranger such as myself.

My thanks also go to Carol and Darwin Apel, for the things they have provided me that go above and beyond the mere scope of a book; to Michael Bonnell for the support I needed to be able to stay up late at night and get this done; and to Hayden Bonnell for being such a trooper as we hiked from here to there and back to acquire images, and for napping two hours each day so I could work.

A special thank you also goes to Samantha Gleisten, my editor, whose encouragement, support, enthusiasm, and friendship has made this project so much fun to work on.

The most important acknowledgment of thanks goes to Mindy S. Apel, who provided me with assistance in research, photography, layout, and so much more. Without Mindy's tireless efforts on behalf of this book and her amazing enthusiasm for the final result, I know that I would never have been able to accomplish this monumental task. In truth, I consider this "our book."

This book is dedicated to my family, friends, and neighbors with whom I grew up in the best neighborhood a person could hope to live in: Lincoln Park, Chicago.

—Melanie

INTRODUCTION

It is a neighborhood rich in its diversity, with so many things to do that one might never need to leave. Grocery stores, the neighborhood's oldest pharmacy, homes, apartment buildings, banks, bookstores, restaurants, bars, beauty salons, museums, schools, hospitals, the country's only remaining free zoo, playgrounds, a conservatory, a lagoon, and a full park... This mini-cosmos is none other than Chicago's Lincoln Park neighborhood.

One of the most traditional yet modern upscale neighborhoods on Chicago's north side, Lincoln Park is over 150 years old. Over the last century-and-a-half the neighborhood has undergone some of the most provocative changes while remaining steadfastly the same. Lincoln Park's boundaries have changed over the years, and even today, the answer to exactly what area makes up the neighborhood depends on who one asks. Once a city unto itself, Lincoln Park's boundaries were North Avenue, Halsted Street, Fullerton, and Lake Michigan. For the purpose of this book, today's boundaries of Diversey Parkway on the north and North Avenue on the south, Ashland Avenue to the west and Lake Michigan to the east, define what will be considered the Lincoln Park neighborhood.

Lincoln Park, Chicago uncovers the history of Chicago's beautiful Lincoln Park neighborhood from as far back as before 1871's Great Chicago Fire. One needs only walk down any street in Lincoln Park to get a glimpse of its incredible history. Within the neighborhood is the country's only free zoo, a home that survived the Chicago Fire, an elementary school built just in time to shelter refugees of the Great Chicago Fire, mansions, statues, monuments and museums, live venues, bustling shopping on Clark Street... It is an urban area with something of an unpretentious, small-town feeling. Today, Lincoln Park is a culmination of past and present, turn-of-the-century and modern rehab.

Historic photographs acquired from such institutions as the Chicago Historical Society, the DePaul University Archives, the Chicago Academy of Sciences, and Lincoln School, as well as from neighbors who have resided in the neighborhood for many years, paired with current photographs taken by Lincoln Park resident and native Mindy S. Apel, tell the story of this beautiful neighborhood.

For the purposes of this book, Lincoln Park, the neighborhood, must be distinguished from Lincoln Park, the park, although at times the two seem somewhat interchangeable. The park itself, once a vast, barren sand dune, stretches from Ohio Street on the south end of Chicago to Ardmore on the North. The neighborhood runs alongside twelve blocks of the park from North Avenue to Diversey. Incorporated in 1837, the neighborhood was once a town unto itself. Called North Chicago, along with its neighbor to the north, a suburb called Lake View, the two towns made up the Lincoln Park District. Eventually, Lincoln Park, the neighborhood, was settled by predominantly German immigrants at a time when land was cheap, only $150 per acre. Purchases set up boundaries for the area, most of which remained barren prairie throughout the 1800s. Because it was considered remote, the area was home to not only a smallpox hospital but a large cemetery, as well. In 1852, a cholera epidemic necessitated the purchase of land outside the city limits in order to erect a hospital and quarantine stations. Fifty-nine acres, enclosing an area from Diversey to Lake Michigan to Fullerton to Lake View, were purchased for a mere $8,851.50. However, before anything could be built, the epidemic was brought under control and the swamp

and sand-filled land remained unused until it became part of Lincoln Park in 1869.

Lincoln Park began to see true growth in 1859, however. Three of Chicago's leaders, railroad men William Ogden and Joseph Sheffield and brewery owner Michael Diversey, together made a donation of 25 acres of land on which DePaul University now stands. The Germans of the neighborhood were joined by Irish and Scottish neighbors shortly thereafter.

However, Lincoln Park did not actually become Lincoln Park until after President Lincoln's death in 1865. Before the assassination of the 16th president of the United States, Lincoln Park had been called Lake Park.

Following the Great Chicago Fire in 1871, which wiped out almost everything southeast of Lincoln Avenue (at Larrabee), a massive effort to rebuild the neighborhood between 1880 and 1904 resulted in more than half of the Lincoln Park buildings that stand today, plus a huge growth in its population. Although after the fire the City of Chicago adopted the Fire Ordinance of 1872, which required fireproof structures, Lincoln Park was exempt for a time. Thus, many working class neighbors built frame houses, later called "Chicago cottages." However, the wealthier neighbors, the German immigrants, built stately mansions in the neighborhood.

By 1920, Lincoln Park was home to nearly 95,000 people. Although the neighborhood remained a high-class residential area in the 1930s and 1940s, its reputation began an unfortunate decline in the 1950s. Following World War II, when many single family homes had been turned into rooming houses, more than a few families sought a quieter existence in the suburbs. In fact, some streets in Lincoln Park, such as Cleveland Avenue, were known as "bad parts" complete with houses of ill-repute.

The 1970s saw things beginning to turn around again. Rehabbing caught on and many neighborhood houses were restored or gutted and completely redesigned on the inside, their frames remaining virtually untouched as part of an architectural landmark program.

More recently, although still inhabited by the same families who lived in the neighborhood 40 or 50 years ago, the neighborhood has taken on somewhat of a "yuppie" tone, with many young professionals renting apartments for well over $1,000 a month, just to be in the heart of it all.

A book of this size cannot possibly capture the scope of the entire neighborhood, every home, street, monument, person, business, or event. However, the pages that follow offer a taste of what the neighborhood was once like, showing just how much things have changed and just how much they have remained the same.

Its history is rich, its neighbors are family, it is a great place to grow up, and it always has something new to offer to those who've spent their lives here, as well as to those just passing through. It is Lincoln Park.

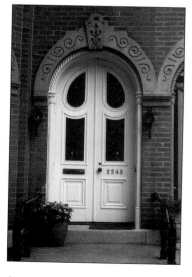

This beautiful set of double doors at the entryway of 2243 N. Geneva Terrace has a unique story. Originally belonging to the coach house behind 2241 N. Geneva Terrace, the doors had fallen into horrible disrepair. So horrible, in fact, that the doors had found themselves in the alley on numerous occasions, but garbage collectors would not take them away. When the owners of 2243 purchased their house they claimed the doors for themselves, stripped and repaired them and had all but one original pane of glass replaced with period glass. A photo of the newly refurbished doors would eventually end up on a poster depicting doors of the neighborhood. (Photo courtesy of Mrs. Norman Barry.)

One

FIRE!

Chicago was a growing city in the late 1800s. Lincoln Park was no exception. Small shops and wood-frame homes had begun to fill empty prairie space in this area. A new elementary school named for Abraham Lincoln was erected. Lincoln Park was finding its niche as a Chicago neighborhood. The night of October 8, 1871 changed the city, and Lincoln Park, forever. That fateful Sunday night, a fire broke out. Chicago was no stranger to fires, but this fire was different. This fire would become the yardstick by which all other disasters would come to be measured. For 31 hours fire licked the north side of Chicago, leaving four miles of devastation that reached Fullerton Avenue. The eastern portion of Lincoln Park was nothing but rubble. More than 17,000 buildings—many of them Lincoln Park homes—were destroyed in what became one of history's most famous fires: The Great Chicago Fire of 1871.

Lincoln Park's Engine 22 was among the first hook and ladder companies to arrive on the scene...

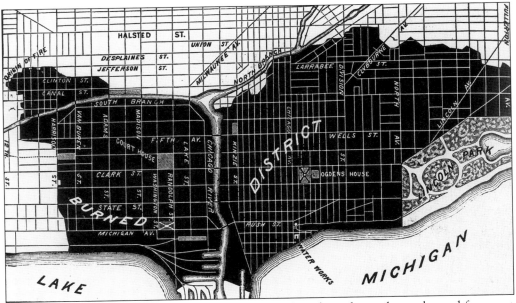

Although four miles were burned from south to north and another mile was burned from east to west in the Great Chicago Fire of 1871, only about one quarter of the burned district was within the Lincoln Park neighborhood. Nevertheless, roughly one quarter of the neighborhood was destroyed by the fire. The actual park, now called Lincoln Park, shown at the right, was a cemetery at the time of the fire. Refugees waited in the cemetery and waded in Lake Michigan to escape the heat of the flames until they were forced to flee further north. (Photo courtesy of the Chicago Historical Society.)

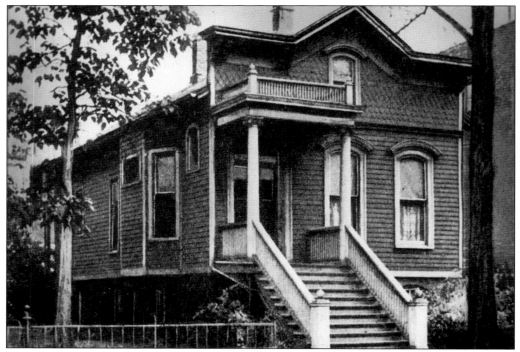

This photo was taken just one year before its subject would become famous. The home at 2121 North Hudson is perhaps the most well known Great Chicago Fire survivor. At the time of the fire, Chicago policeman Richard Bellinger owned the house. There are several different versions of the story of how Officer Bellinger was able to save his house from the mass destruction that leveled his neighborhood. One story is that he quickly tore up the wooden sidewalks and fence and then got rid of all the leaves from around the house and then he and his brother-in-law snuffed out sparks as they landed. (Photo courtesy of Lincoln School.)

Today the south corner of the front of the Bellinger House bears this plaque, which reads, "This Is Policeman Bellinger's Cottage Saved By His Heroic Efforts From The Chicago Fire October 1871." (Photo by Melanie Ann Apel.)

10

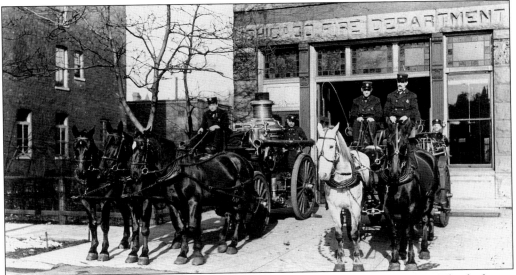

Engine 22's firehouse was unique in that it was three stories tall, rather than two. The firehouse was built to house the well-cared-for horses, whose stables were in back behind the apparatus, and the horse-drawn, steam-operated engine on the ground floor. The firemen slept on the second floor and played handball with neighbors and police officers on their own handball court on the third floor. Looking closely at the building, just below the words "Chicago Fire Department" in this 1917 photo, one can see beautiful stained glass windows. The rather important-looking man all the way to the right is Captain Michael McDonald. Captain McDonald's son William would later become captain of Hook and Ladder 10, 1613 N. Hudson. (Photo courtesy of Ken Little/Fire Museum of Greater Chicago.)

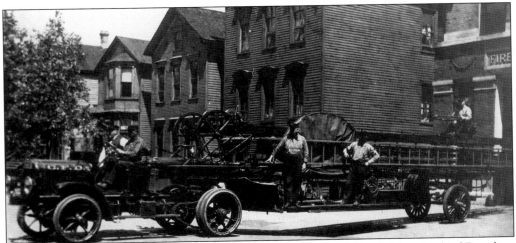

Another firehouse assigned to the Lincoln Park neighborhood was Truck 10 with Third Battalion Headquarters, located at 1613 N. Hudson. This photo of the Truck 10 firehouse was taken around 1918. All of the buildings along Hudson Street remain standing today except for the firehouse, which only stood on this spot from 1906 until 1964. The motorized rig in this photo was the first one owned by this firehouse and one of the first in the City of Chicago. At the rear of the fire truck (on the right of the photo), the tiller man sat up high to steer the rear part of the motorized tractor-trailer. The 65-foot ladder along the top of the truck was operated both manually and with a spring system. (Photo courtesy of Ken Little/Fire Museum of Greater Chicago.)

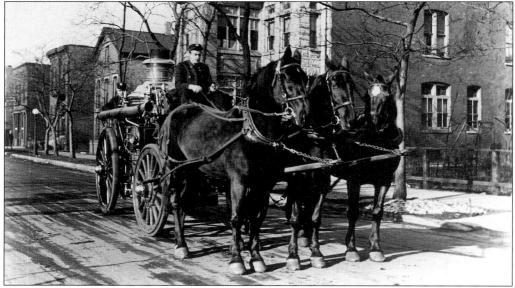

From 1890 until 1970, Engine 22 was stationed at 522 W. Webster. This fire station covered Lincoln Park from Eugenie to Wrightwood and was first due to all fires in this area. This photo, looking west on Webster toward Larrabee c. 1920, shows Engine 22 just before a motorized apparatus replaced the horses. The original wood frame firehouse, which stood on this site from 1870 to 1890, responded to the Great Chicago Fire of 1871. Although the building and the entire 500 block of west Webster survived the fire, Hose Company 4's hose wagon was lost in the inferno. The original Hose Company had only three firemen. (Photo courtesy of Ken Little/Fire Museum of Greater Chicago.)

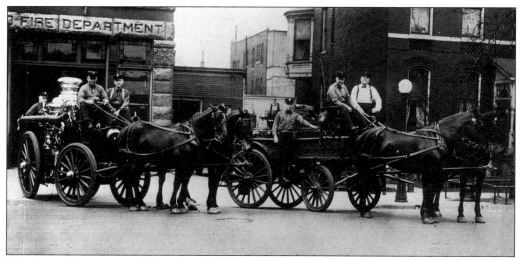

The horse-drawn era ended in the early 1920s. This 1921 photo of Engine 22's Engineer Max Leslie, Fireman William Wirmerskirchen, Fireman Roy Erbe, Lieutenant Fred Stift, and several others, shows part of a home that still stands on Webster just east of Grant Hospital. If one were to visit the site today, one would see yet another home just east of the one in this photo. Of particular interest is the fact that the house comes so close to pedestrian traffic. The reason is that the house was, until probably the 1940s, a small grocery store. Its awning read "Food Shop." (Photo courtesy of Ken Little/Fire Museum of Greater Chicago.)

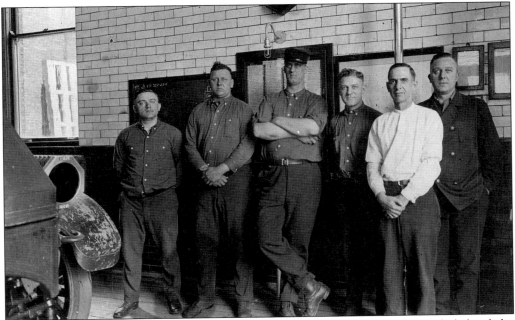

Firemen posed inside the Hudson Street Fire Station in the 1920s. The fire pole behind the second man on the right was made of brass. Of curious note, the brass fire pole, or sliding pole, was invented in Chicago. This firehouse stood behind, southeast, of St. Michael's Church. (Photo courtesy of Ken Little/Fire Museum of Greater Chicago.)

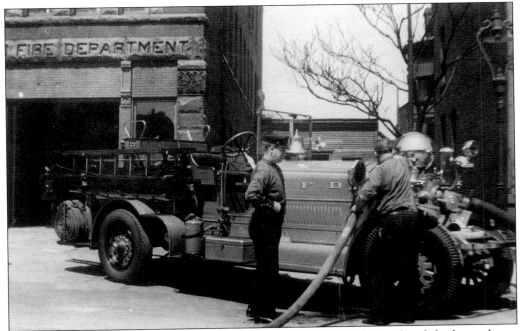

In 1921, the Ahrens-Fox Pumper, shown in this photo, c. 1940–1941 replaced the horse-drawn engines. At the front of the engine, just over the fireman on the right's right shoulder, is a large, shiny ball, which regulated pressure. This was part of a piston pump. Engine 22 used this Ahrens-Fox Pumper until the late 1940s. (Photo courtesy of Ken Little/Fire Museum of Greater Chicago.)

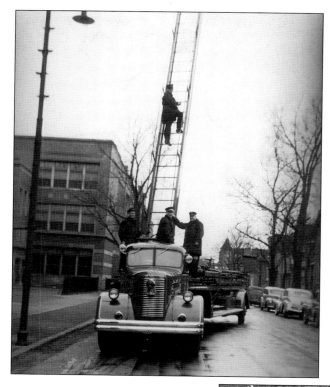

It was important for the firemen to run ladder drills. Around 1946, the Hudson Street firemen ran this aerial ladder drill at nearby St. Michael's Elementary School. (Photo courtesy of Ken Little/Fire Museum of Greater Chicago.)

Around 1947, yet another aerial ladder drill was captured on film. This time, the firemen ran their drill outside of St. Michael's High School. Although St. Michael's Elementary School was eventually razed, the building that housed St. Michael's High School from 1887 to 1978 still stands. However, it is no longer a high school. The building was remodeled and is now home to condominiums. (Photo courtesy of Ken Little/Fire Museum of Greater Chicago.)

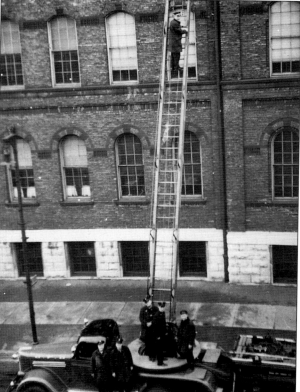

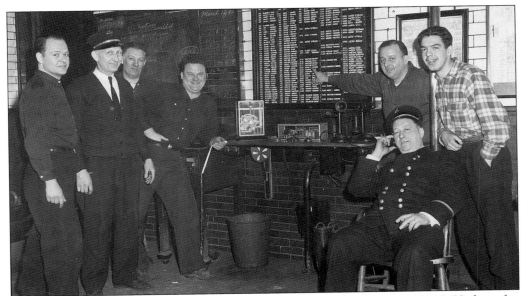

Inside the firehouse, Hook and Ladder Company 10, Third Battalion, at 1613 N. Hudson, fire personnel gathered for this March 1948 photo. From left to right are Fireman Harry Cieslak, Lt. Walter Kuszynski, Fireman Jack Schultz, the driver of the 3rd Battalion, also known as the "Buggy Driver," Fireman Eddie Hoehn, Fireman Bill Gunther, and Chief Joseph S. Walsh. The young man at the far right is 15-year-old Ken Little. Mr. Little was such an ardent fan of the firehouse that, although never a firefighter himself, Mr. Little enjoyed a long career as a civilian working for the fire department's communications department. Today, Ken Little is the historian for the Fire Museum of Greater Chicago and has written several large reference books on the history of the Chicago Fire Department. (Photo courtesy of Ken Little/Fire Museum of Greater Chicago.)

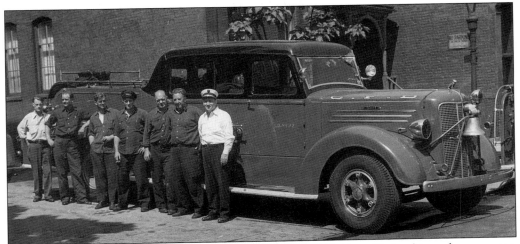

Looking very oddly out of proportion to the men of Engine 22 is this sedan pumper, photographed in the driveway just east of the Fire Station in the early 1950s. The sedan pumper could pump up to four hose lines at once and 1,000 gallons of water a minute. It carried the hose and the firemen and even a few curious neighbors at times. The firemen appreciated the enclosed ride when answering calls in bad weather. However, the sedan was so large that it often had difficulty maneuvering down the sometimes-narrow streets of Lincoln Park. (Photo courtesy of Ken Little/Fire Museum of Greater Chicago.)

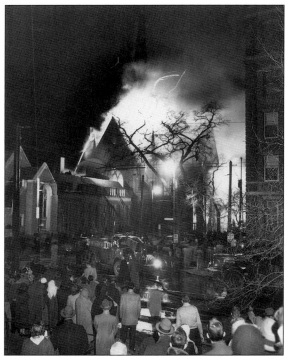

The year 1955 was difficult for the St. Pauls United Church of Christ congregation. Two prominent members, department store founder William Wieboldt and meat packing company founder Oscar F. Mayer, both died. Renovations on the 1898 sanctuary were completed just weeks before Christmas. On Christmas Night 1955, a terrible fire destroyed the newly renovated 1898 sanctuary building. Horrified onlookers stood along Fullerton and Orchard Avenues at the corner of Children's Memorial Hospital and watched the blaze. An NBC television news film of the fire shows the roof giving way, taking the church tower down with it. (Photo courtesy of St. Pauls United Church of Christ Archive.)

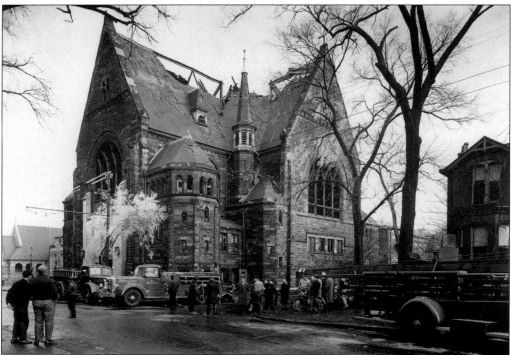

December 26, 1955, the morning after, looking north on Orchard Street from Fullerton Avenue, the sanctuary of St. Pauls United Church of Christ stands mortally wounded. The only one of three church bells to survive the fire sits in the church courtyard today. (Photo courtesy of St. Pauls United Church of Christ Archive.)

This photo shows the inside of the sanctuary of St. Pauls United Church of Christ after the last embers of the 1955 Christmas Night Fire cooled. The fire destroyed hand-crafted woodwork, art glass windows, and murals hand-painted in the 1920s by German artist Gustav Brand. The fire was blamed on a short in the wiring of the church organ, which had just been installed, its pipes decoratively painted in time for Christmas Eve services. (Photo courtesy of St. Pauls United Church of Christ Archive.)

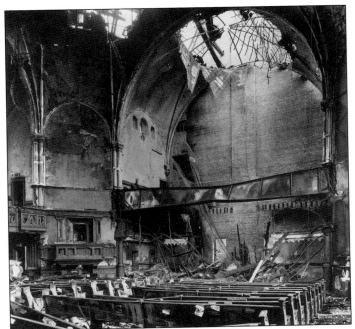

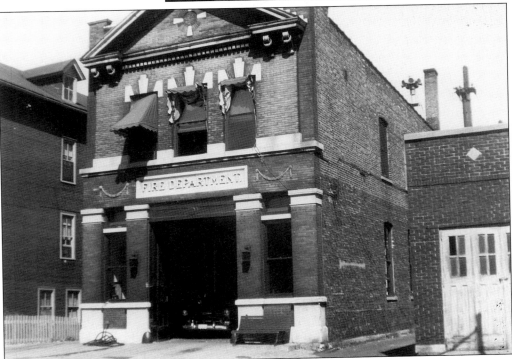

This photo, taken in 1955 or 1956 by Ken Little, shows the front of Hook and Ladder Company 10 at 1613 N. Hudson. The awnings on the front of this building were, reportedly, green. Behind the three windows overlooking Hudson Street was one very large office occupied by the firehouse's first fire chief. His desk, bed, and files filled the entire front section of the building's second floor. Later, two chiefs would share the space. (Photo courtesy of Ken Little/Fire Museum of Greater Chicago.)

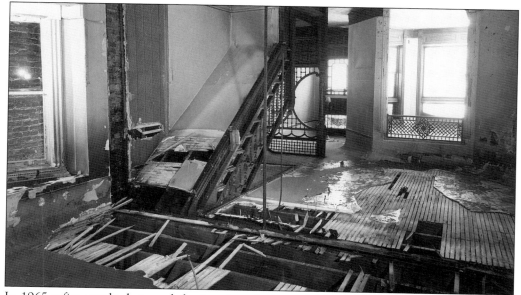

In 1965 a fire nearly destroyed the interior of a beautiful house on the 2200 block of North Fremont. No one knows exactly how the fire was started, and no one was hurt, but the damage required almost complete renovation of the interior. This photo of the first floor living room and front entrance shows the aftermath of the fire, before work was started to renew the house. (Photo by Donna Lee Johnson/Courtesy Mary Beth Canfield.)

On May 11, 1971 Engine 22 relocated to 605 W. Armitage, where there was room for a new three-apparatus bay instead of the single-apparatus bay. The move also allowed Grant Hospital to expand. Engine 22's new building was originally an electrical appliance store that also sold 78 LP records and even had a place inside in which shoppers could listen to the records before making a purchase. Today, Lincoln Park's first fire company still responds to the neighborhood's fires. It also has an ambulance and a Hazardous Materials van. The other firehouse that has been responding first to alarms in Lincoln Park since 1965 is the firehouse at 2718 N. Halsted. The Halsted firehouse replaced an original 1884 combined fire and police building at 2740 Sheffield, which was then part of the City of Lake View. (Photo by Mindy S. Apel.)

Two
BUILDING A NEIGHBORHOOD

Many of Lincoln Park's residents have owned homes in the neighborhood since the days when Lincoln Park was merely a name and not a status symbol, and real estate could be purchased for what today would be considered a down payment. Generations of Lincoln Park residents live in homes that are untouchable landmarks. With the landmark Mid-North District in its midst, Lincoln Park displays homes built in architectural styles dating back to the late 1800s. Architectural styles include some pre-Chicago Fire wooden cottages that survived the blaze, masonry residences designed in Richardsonian Romanesque and Queen Anne styles, Prairie School, Baroque, Georgian, and Italianate-style rowhouses.

A massive effort to rebuild the neighborhood between the 1880 and 1904 following the Great Chicago Fire of 1871 resulted in more than half of the Lincoln Park buildings that stand today...

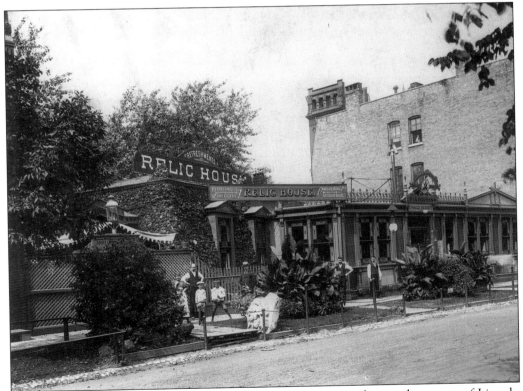

One has to use the imagination to picture the Relic House standing at the corner of Lincoln Park West and Clark Street. The Relic House was a beer garden featuring Anheuser-Busch beer from Wisconsin, refreshments, and fine cigars. The William Lindemann Family Resort was adjacent to the Relic House. (Photo courtesy of the Chicago Historical Society.)

Built in 1872, the Relic House was torn down in 1929 in favor of an apartment building. The Relic House originally stood at the corner of Clark Street and Center Street (now known as Armitage), but was moved to the corner of Clark Street and Lincoln Park West in 1883. The Relic House, a "renting library" of books and magazines, had a popular beer garden behind it for 60 years. The Relic House was a decorative building made of molten iron, glass and china. The tall building off to the left is the Pierre, another long-time Lincoln Park structure. (Photo courtesy of the Chicago Historical Society.)

Into the 1880s, cast iron was frequently used in the internal construction of many buildings in Lincoln Park. (Photo courtesy of the Chicago Historical Society.)

Abstract of Title

TO

The E 25 ft of Lt 4 in sub of

N 81 84/100 ft of Blk 31 in

Can Trs' Sub of Sec. 33,4-,14,

in Cook Co.,Ills.

FOR

Shepard,McCormick & Thomason.

CHICAGO TITLE AND TRUST COMPANY

ASSETS EXCEED $8,000,000

ABSTRACTS OF TITLE TITLE GUARANTEES
GENERAL TRUSTS

TITLE AND TRUST BUILDING
CHICAGO, ILLINOIS

ACCEPTS ORDERS FOR THE

Allman-Gary Title Company

to property in Gary and all other points in Lake County, Indiana

| No. 796972. | Vol. | Page |

"The Abstract of Title to the E 25 ft of Lt 4 in sub of N 81 84/100 ft of Blk 31 in Can Trs' Sub of Sec. 33, 4?, 14, in Cook Co., Ills.," describes the plot of land on which a two-flat brick building on the 300 block of Dickens Avenue now stands. This Abstract of Title holds information about the land dating back to 1843, at least 40 years before the house was built. Neatly handwritten and typed legal documents describe how the land traded hands many times, and how an 1830 congressional act stated that "these lands were selected" to be granted to the State of Illinois to build a canal connecting the Illinois River to Lake Michigan. (Courtesy Darwin R. Apel.)

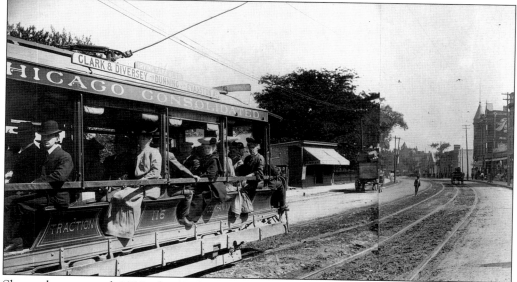

Shown here around 1900, this is the corner of Broadway, Clark, and Diversey, where the Lincoln Park neighborhood gives way to the Lake View neighborhood. (Photo courtesy of the Chicago Historical Society.)

This image of Clark Street looking south at Diversey c. 1900 was captured in two photographs that were later pieced together. Today this corner is the busy, bustling, five-corner intersection where Clark Street crosses Diversey Parkway and Broadway meets the two. Walgreens, Borders Books and Music, Jamba Juice, Hanigs Slipper Box, and Coconuts Music flank the corners. (Photo courtesy of the Chicago Historical Society.)

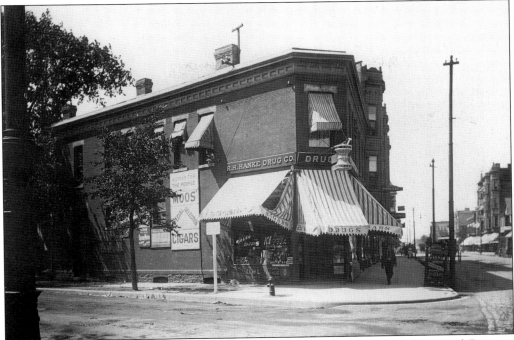

This photo shows a different view of the intersection of Clark Street, Broadway, and Diversey Parkway in 1900. Today, Diversey Parkway, named for Michael Diversey, owner of the Diversey & Lill beer brewery and donor of the land on which St. Michael's Church stands, is the dividing line between the northernmost end of Lincoln Park and the southernmost end of the Lake View neighborhood. (Photo by Lissan Kanberg Jr./Courtesy the Chicago Historical Society.)

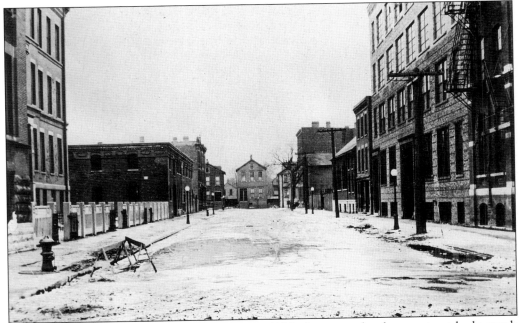

Looking north on Orleans Street at Eugenie in 1920, this somewhat barren street looks much different today. (Photo courtesy of the Chicago Historical Society.)

Built around the turn-of-the-century, this is the Webster Street "el" stop in the 1920s. Today there is no Webster Street stop. (Photo courtesy of DePaul University Library Special Collections.)

Looking south on Orleans toward Eugenie, this is a car barn photographed in 1920. (Photo courtesy of the Chicago Historical Society.)

Today, visitors continue to book rooms at the Hotel Lincoln, which has stood at the corner where Clark Street, Lincoln Avenue, and Wells Street meet, overlooking the park, since approximately 1932. However, the name of the hotel, whose actual address is 1816 N. Clark, has recently been changed to Days Inn. (Photo courtesy of DePaul University Library Special Collections.)

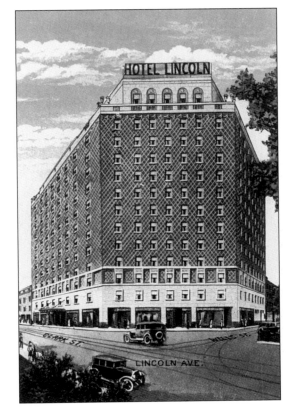

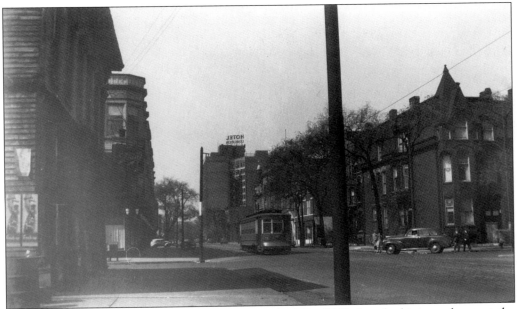

One can see the Hotel Lincoln in the background of this 1947 shot, looking northeast at the route #3 Lincoln/Indiana streetcar running down Wells Street at Eugenie. (Photo by Ed Frank/Courtesy the Chicago Historical Society.)

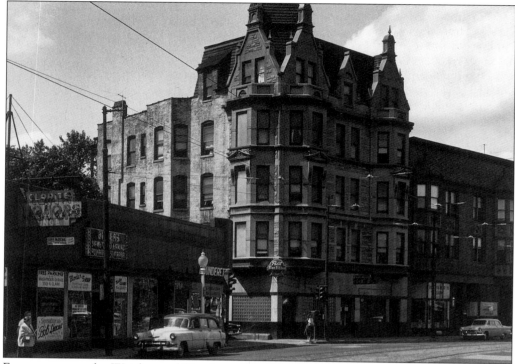

For many years the Wrightwood Hotel stood at 2616 N. Clark Street at Wrightwood. In this September 10, 1956 photo, one can see trolley tracks running down Clark Street. Today, the beautiful Wrightwood Hotel façade remains, but the hotel is long gone. Many different shops have occupied the street level storefronts. The floors above are apartments. The building just north (right) of the Wrightwood Hotel building was torn down and the space is occupied by perhaps Lincoln Park's most often-visited hot dog stand, the Wieners Circle. The building to the left has been home to Affordable Portables for more than 25 years. (Photo by Glenn Dahlby/Courtesy the Chicago Historical Society.)

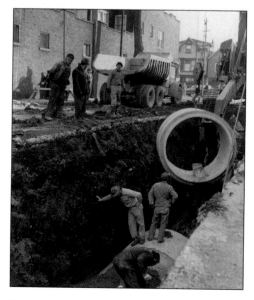

Many buildings in Lincoln Park have a first floor that sits about ten feet lower than street level. This is because rather than dig up the streets, sewers were laid on top of the streets and then covered over by a new street ten feet higher than the original. This photo, taken on February 13,1954, shows workers placing a six-foot pipe for the Wrightwood sewer just north of Fullerton Avenue on Rockwell Street. (Photo by Evelyn Lambecht/ Courtesy the Chicago Historical Society.)

At 2300 Lincoln Park West, across the street from the Conservatory and Lincoln Park Zoo, is the Belden-Stratford Hotel. Both a long- and short-term apartment building, as well as a hotel, the Belden-Stratford was gutted and remodeled in the 1980s and is now one of the most luxurious places to live in Lincoln Park. Located inside the Belden-Stratford are a salon, a fitness center, and The Ambria and Mon Ami Gabi, two of the fanciest restaurants in Chicago. The Belden-Stratford, built in 1922, was declared a Lincoln Park landmark in the 1970s. (Photo courtesy of the Belden-Stratford Hotel.)

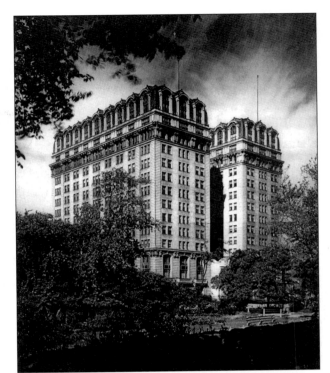

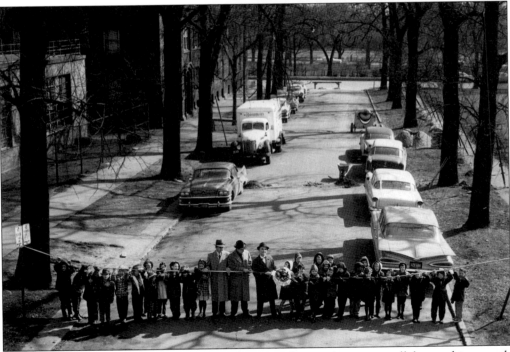

In the late 1960s, the end of Grant Place, the street that used to run parallel to and just north of Webster straight through to Clark Street, was closed off to make a cul-de-sac of sorts, with Sedgwick running into Grant Place. Students of Francis W. Parker School were on hand for the official street closing. (Photo courtesy of Francis W. Parker School.)

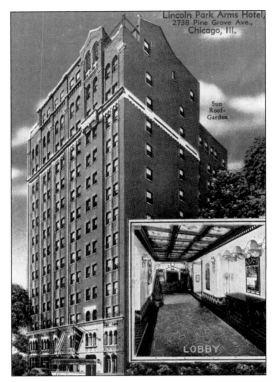

The Lincoln Park Arms Hotel, which advertised a sun roof garden, has stood at 2738 Pine Grove since sometime in the 1920s or 1930s. Built as a wedding gift, the hotel has always been an apartment building. Legend has it that at one time Al Capone used the penthouse to "fraternize" with ladies of the night, and for drinking and gambling. (Photo courtesy of DePaul University Library Special Collections.)

Looking north down the 2200 block of North Lincoln Avenue in 1983, one could see the front part of an old Chevrolet hanging from a building as a sign. This photo, taken by John McCarthy, also shows Bruce and Doris Oxford's Oxford Pub, the Victory Gardens Theater/Body Politic Theatre, and the Twenty-three 50 Restaurant and Pub. Of these, only the theatre is still open today. (Photo courtesy of the Chicago Historical Society.)

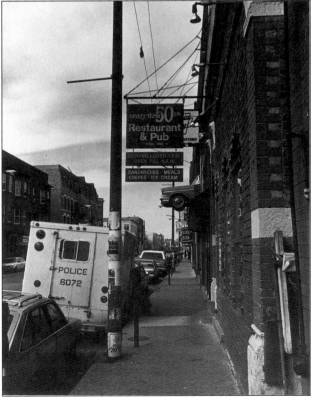

Three

OFF TO SCHOOL

A neighborhood is not a neighborhood without children. And where there are children, there must be schools. Although Lincoln Park has at least half a dozen public elementary schools and a share of parochial schools as well, the school most often associated with Lincoln Park is Abraham Lincoln Elementary, known by neighbors as simply Lincoln School. Construction of Lincoln School was completed shortly before the Great Chicago Fire of 1871, just in time to house many of the fire's refugees. A few blocks south of Lincoln School is Lincoln Park High School, the neighborhood's only public high school. Originally called Waller High School, LPHS, as neighbors call it, is not only a neighborhood school but a magnet school as well, attracting students from all over the city. Lincoln Park has only one private independent school, Francis W. Parker School, which educates children from junior kindergarten through 12th grade.

Many other schools have come and gone in a neighborhood known for its well-educated children...

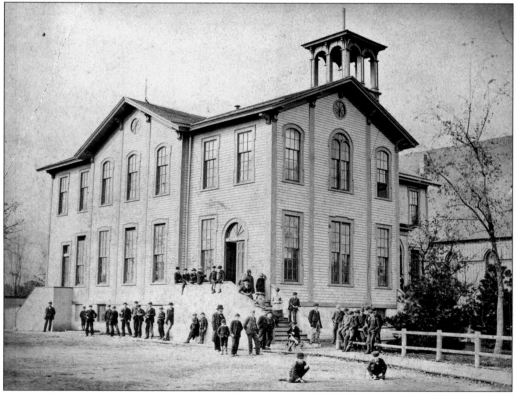

Lincoln Park was once home to Kenwood School, pictured here with a number of students and a few faculty members in 1880. The building on the right of the photo is St. Pauls Church. (Photo courtesy of the Chicago Historical Society.)

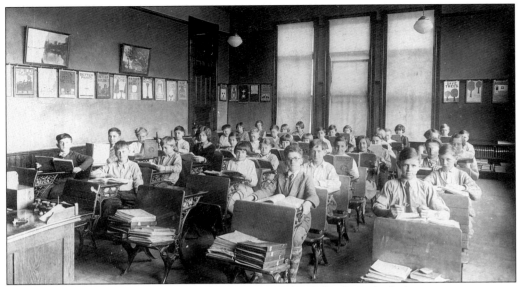

Even back in the early 1900s, students at Lincoln School studied the environment, as evidenced by the assignments hung around the classroom in what is now referred to as the "old building" of Lincoln School. The door to the rear left of the classroom leads to the cloakroom. This wing of Lincoln School remains without lockers today and students still hang their coats in the old fashioned cloakrooms. This photo was taken sometime between 1900 and 1920. (Photo courtesy of Lincoln School.)

This 1937 photo shows Lincoln School as it looked when it was built in 1871. (Photo courtesy of Lincoln School.)

The leader of the Lincoln School lunch room ladies was Bessie LaSalle, pictured here in February 1968, with her chin up and glasses sparkling. Bessie was probably the best known of any lunch room lady to students in the 1960s and 1970s. Taking a break from their work and lunching on cafeteria food with Bessie are (back left) Lola Matelli, (front left) Mary Penge, and (front right) Margaret Delporte. (Photo courtesy of Lincoln School.)

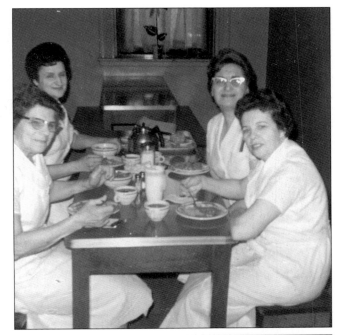

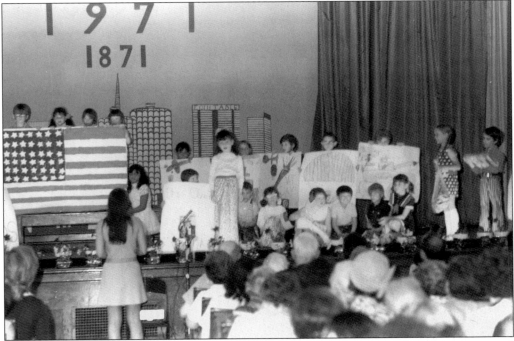

In 1971, the students and faculty of Lincoln School celebrated its centennial with patriotism and school spirit. Built just before the Great Chicago Fire of 1871, Lincoln School on Kemper Place, tucked behind Fullerton Avenue and Children's Memorial Hospital, became the temporary shelter for many families who lost their homes in the devastating fire. Now more than 130 years old, Lincoln School is on its 17th principal. It is interesting to note that of the 17 principals of the school, 11 have been women. The very first principal of the school was Marie H. Hoven, who served only one year. (Photo courtesy of Lincoln School.)

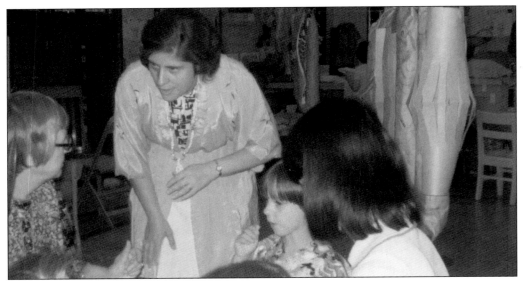

For 15 of the 18 years that she taught kindergarten at Lincoln School, Nancy Stocking's class took part in a very special social studies project. Paired with sister city Tokyo, Japan, Mrs. Stocking's class enjoyed a week-long lesson on Japan, culminating in a Japanese luncheon, complete with Japanese foods and traditional Japanese dress. The students made Japanese shoes, lanterns to string across the classroom, a rickshaw, and tatami mats to sit on. In this 1976 photo, Mrs. Stocking, dressed in Kimono, shared a moment with Lincoln School principal Mary Alice Cullen, who presided over the school from 1965 until 1980, when poor health forced her retirement. Miss Cullen died in 1993. Mrs. Stocking, who began teaching first grade at Lincoln School in 1962, moved to kindergarten the following year, where she stayed until her 1981 return to first grade. After 40 years, Mrs. Stocking retired from teaching in June 2002. (Photo courtesy of Apel Family collection.)

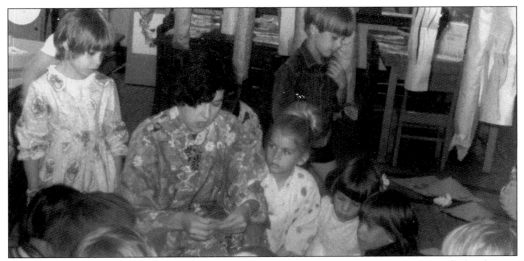

Parents were encouraged to assist with Mrs. Stocking's Japanese Day. Many helped Mrs. Stocking bring the rich tradition to 15 years of kindergarten classes through dance, music, storytelling, movies, food, and art. Here, Lincoln Park resident and Lincoln School parent Betty Hand shows Margeaux Harbison, Stacey Ventura (seated), Amy Barker (seated), and others the art of Origami, Japanese paper folding. (Photo courtesy of Apel Family Collection.)

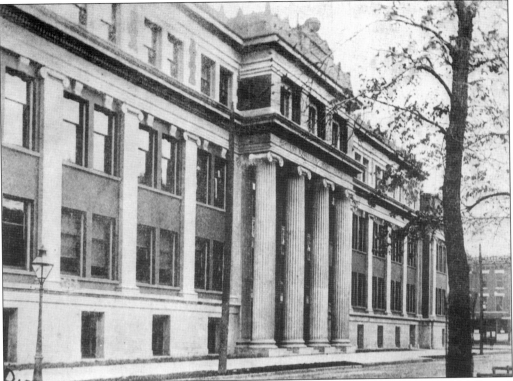

Lincoln Park High School, which stands at Dickens Avenue, Orchard Street Mall, and Armitage Avenue, was built in 1899. This photo of the high school looking south toward Center Street, now Armitage Avenue, was taken in 1903, when the school was called Waller. (Photo courtesy of Waller/Lincoln Park High School Archives.)

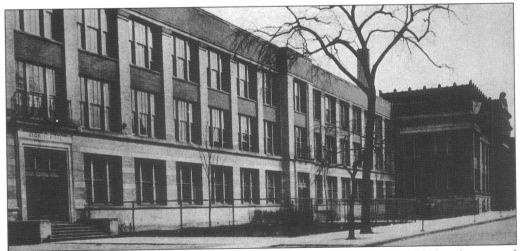

This 1941 photo of Waller High School shows a 1938 addition, which was added to the original 1899 building. The addition, extending north on Orchard Street, added classrooms, offices, two gyms, a pool, and an assembly hall. Twenty-three years later, in 1961, yet another addition was tacked onto the growing neighborhood high school, extending the school into what is now Oz Park. (Photo courtesy of Waller/Lincoln Park High School Archives.)

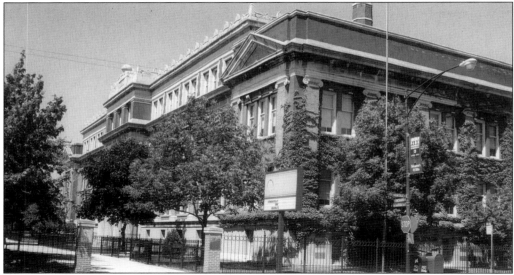

Lincoln Park High School is both a neighborhood high school with a defined attendance area as well as a magnet high school attracting bright students from all around Chicago. In 1980, Orchard Street was closed to traffic to create a mall in front of the school. In 1987, the mall was officially renamed in honor of Dr. Margaret Harrigan in recognition of her work on behalf of LPHS. Dr. Harrigan was named District 7 superintendent in 1976 and was instrumental in changing and revitalizing Waller High School after the turbulent decade of the 1970s, when school enrollment declined as a result of problems with desegregation and academics as well as problems with the building itself. Dr. Harrigan was responsible for the 1979 name change from Waller High School to Lincoln Park High School. Following her role as District Superintendent, Dr. Harrigan became Associate Superintendent of the Chicago Public Schools. She is currently a professor as well as the Director of the Principal's Center at the DePaul University School of Education. (Photo courtesy of Waller/Lincoln Park High School Archives.)

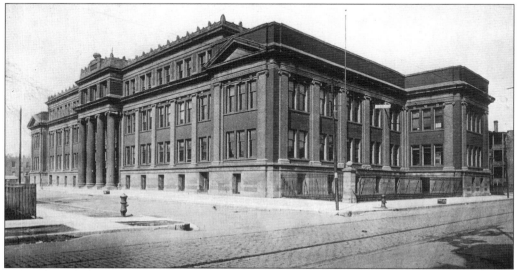

This is how the corner of Armitage and Orchard Street Mall looked in 1919 when the school was called Waller and the street with the trolley tracks was called Center Street.(Photo courtesy of Waller/Lincoln Park Kigh School Archives.)

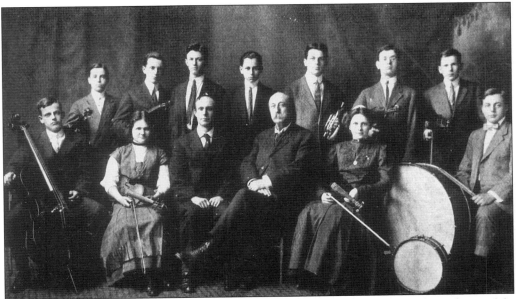

Waller High School Principal Oliver Westcott played flute in the high school's orchestra. Mr. Westcott, the gentleman in the middle of the front row, was Waller High School's principal from 1899 to 1914. (Photo courtesy of Waller/Lincoln Park High School Archives.)

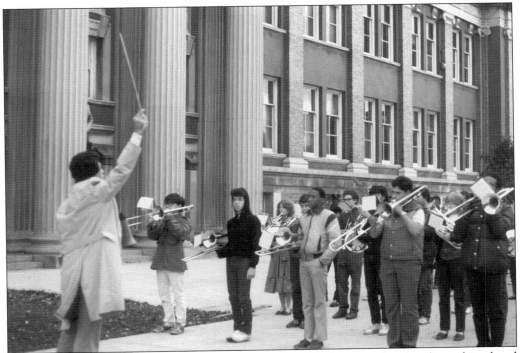

In the 1980s and early 1990s, the Lincoln Park High School concert band and marching band were led by a talented and truly dedicated director and teacher, Mr. George Paris. Under Mr. Paris' intense direction, the LPHS Concert Band won many awards, including a perfect score the first time the band entered Band Fest in 1983. In this photo, c. 1983, Mr. Paris and his Marching Band rehearse on school grounds. (Photo by Samantha Hoffman.)

In the 1920s, Waller High School seniors met every Friday after school for social dancing. Student musicians, known as the Student Dance Band, provided the music while teachers taught the latest dance steps. (Photo courtesy of Waller/Lincoln Park High School Archives.)

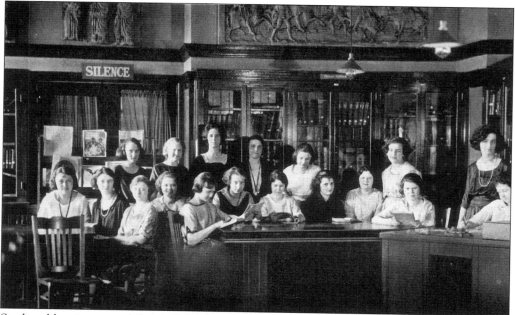

Student librarians pose (silently?) for this 1922 photo in the library of the original 1899 Waller High School building. (Photo courtesy of Waller/Lincoln Park High School Archives.)

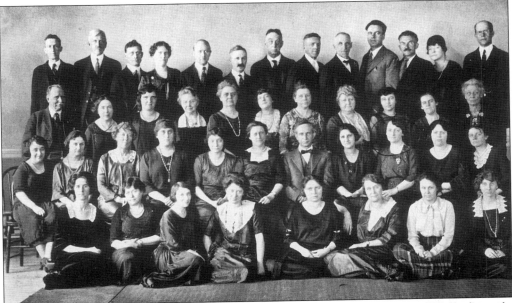

This is the faculty of Robert A. Waller High School in 1922. (Photo courtesy of Waller/Lincoln Park High School Archives.)

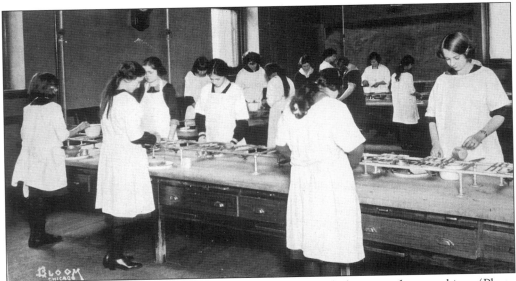

In 1922, Waller High School students enrolled in practical classes, such as cooking. (Photo courtesy of Waller/Lincoln Park High School Archives.)

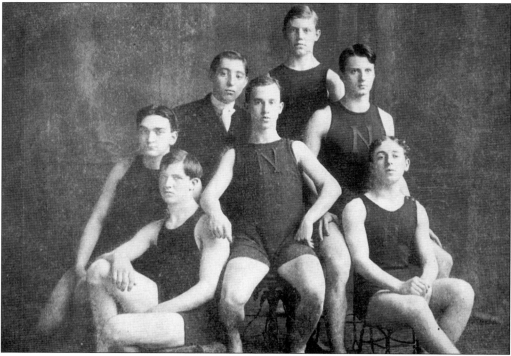

Members of the 1903 Waller High School Water Polo Team posed for the yearbook. The letter "N" on the Waller High School Water Polo Team uniforms stands for North Division. Before the 1899 school building was erected, the high school was known as North Division High School. In 1899, the school name was changed to Robert A. Waller High School, but it took a few years for the name change to be reflected on the school's team uniforms. (Photo courtesy of Waller/Lincoln Park High School Archives.)

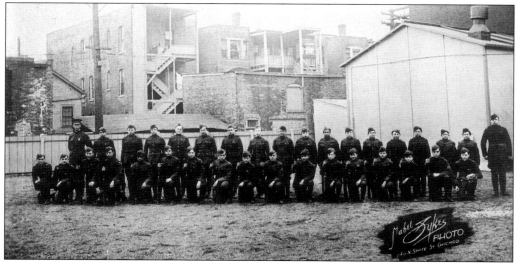

After World War I the Waller High School ROTC was the first unit in the city. Here the ROTC formation stands on the drill field just north of the 1899 building. By 1922 the school was already overcrowded and a portable classroom can be seen on the right. (Photo courtesy of Waller/Lincoln Park High School Archives.)

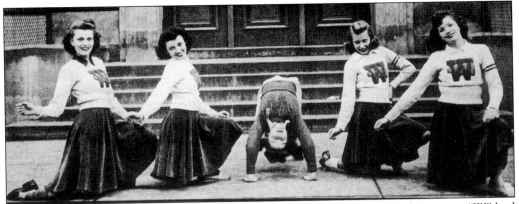

Waller High School Cheerleaders posed for this 1941 yearbook photo. By this time, a "W" had replaced the "N" on their uniforms. (Photo courtesy of Waller/Lincoln Park High School Archives.)

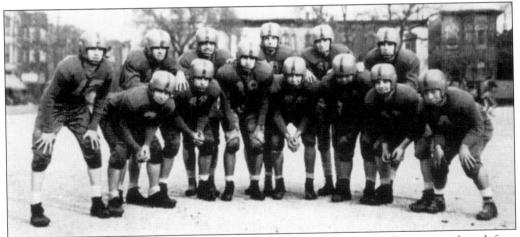

Students who played on the 1948 Waller High School defensive football team are, from left to right, as follows: (front row) Mike Galati, Bill Devoney, Art Kostopoulos, Rudy Maas, George Okada, Sam Priola, and Bob Nakashima; (back row) Ralph Weiser, Jim Rogers, Bob Nicoletti, Roger Seaborg, Nino Riggio, and Robert Stocking. Friends knew Bob Nakashima by the nickname "Dogs" because he was a good friend of another Waller student and enduring Lincoln Park resident named Kats Nakashima. Robert Stocking's brother Marvin, a student of Waller High School from 1954 to 1958, would marry a young woman named Nancy. Nancy Stocking would become the quintessential kindergarten teacher at Marvin Stocking's elementary school alma mater, Lincoln School. (Photo courtesy of Waller/Lincoln Park High School Archives.)

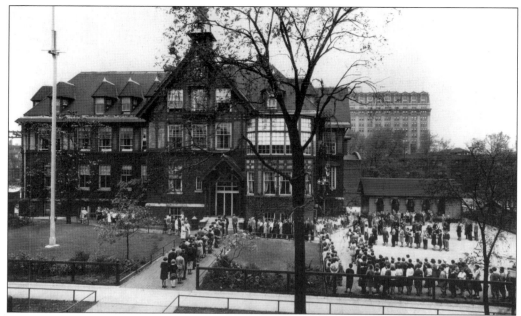

Opened in 1901, Francis W. Parker School is the only independent, private school in Lincoln Park. With a contribution of $3 million and the city block on which the school still stands, Anita McCormick Blaine founded Parker in April 1901. The school educates students from junior kindergarten through 12th grade in a progressive manner focusing on moral, mental, and physical growth, as was the vision of Colonel Francis Parker, for whom the school was named. Although yearly tuition is in the thousands of dollars, innovative educational programs keep more than 700 students engaged in learning every year. Located on the corner of Webster and Clark, this photo shows the original school in 1920. (Photo courtesy of Andrew Kaplan/ Francis W. Parker School.)

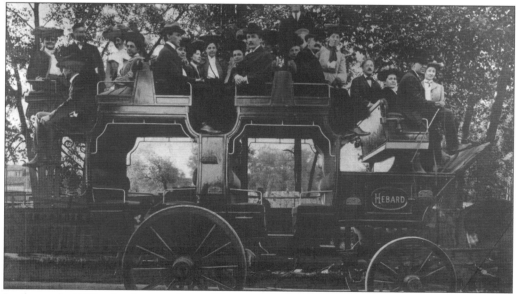

In the early 1900s, faculty members of Francis W. Parker School take a ride through Lincoln Park in a very large carriage. One of the women pictured here is most surely Flora Cooke, the first principal of Parker School. (Photo courtesy of Andrew Kaplan/ Francis W. Parker School.)

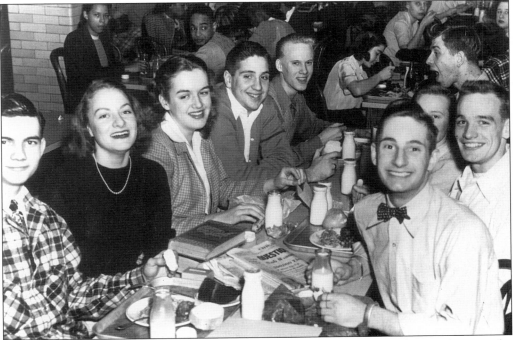

Francis W. Parker High School students said "cheese" for this 1949 lunchtime photo in the school cafeteria. (Photo by Lil & Al Bloom/Courtesy of the Chicago Historical Society.)

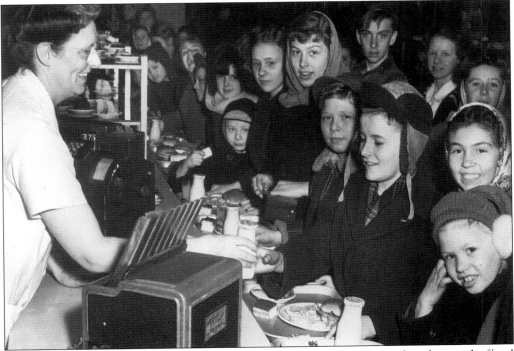

In the 1950s, Parker Elementary School taught a group of what they referred to as deaf/oral students. In 1951, these students queue for lunch. (Photo by Lil & Al Bloom/Courtesy of the Chicago Historical Society.)

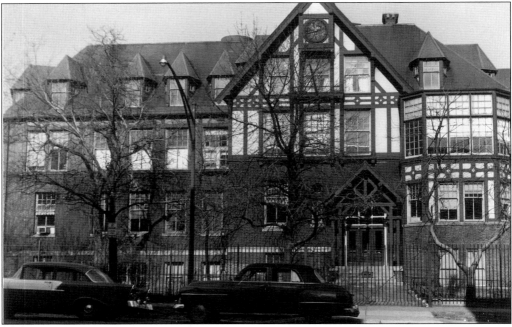

This 1957 photo by Ruth Johnson shows Francis W. Parker School as it once looked, standing at 330 W. Webster. (Photo courtesy of the Chicago Historical Society.)

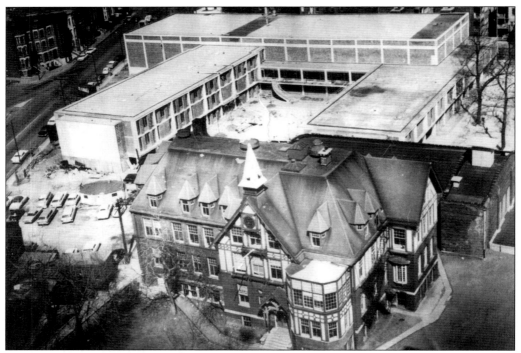

As with most original buildings, the students and faculty of Parker School outgrew theirs. A new building, constructed in 1962, now serves as the center of the campus. Clark Street runs down the left side of this photo. The building in the foreground of this photo no longer exists. (Photo courtesy of Andrew Kaplan/ Francis W. Parker School.)

42

St. Michael's High School stood at 1660 N. Hudson. Built in 1928, the three-story building was converted to 41 condominium units in 1988. (Photo courtesy of DePaul University Library Special Collections.)

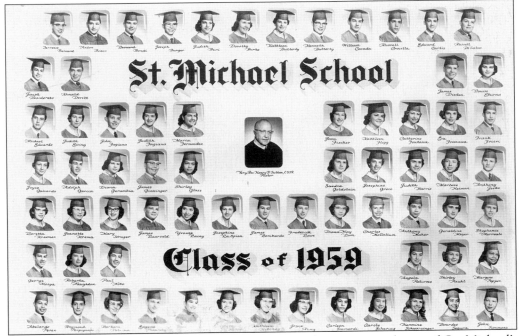

The Very Reverend Henry D. Sutton, C.S.S.R., was the pastor in charge of St. Michael's School in 1959. Even then, the ethnic makeup of Lincoln Park was somewhat diverse. (Photo courtesy of Joan Fischer Stowell.)

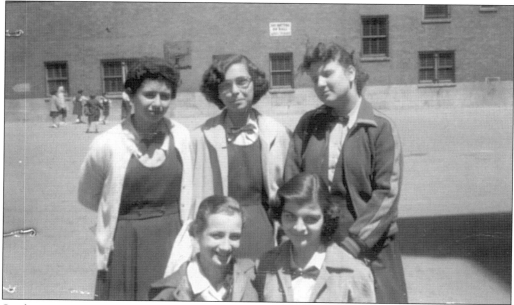

Students are captured in this candid shot on the St. Michael's Elementary School playground on a sunny day in 1958. The building behind the girls is St. Michael's High School, which was open from 1887 until 1978. (Photo courtesy of Joan Fischer Stowell.)

The Harris School, shown here in 1968, stood on the corner of Wrightwood and Lakeview. Harris was a very tiny private school. It was so small, in fact, that the 1958 eighth grade graduating class had all of eight members. The school taught preschool through eighth grade and hoped to open a high school. Due to lack of adequate space, however, the school closed and moved north ito make room for the high school. Its fate is unknown. This building, which was originally one of Lincoln Park's mansions, remains. Following its occupation by Harris School, it was taken over by the Chicago City Day School. Today the somewhat secluded-looking building is occupied by Thresholds North, an educational and support facility for families of individuals suffering from mental illness. (Photo by Sigmund Osty/Courtesy of the Chicago Historical Society.)

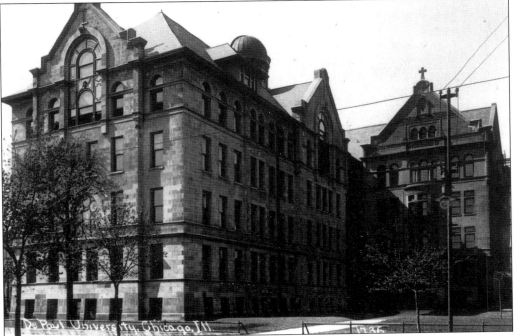

Considered by some as Lincoln Park's University, DePaul University, shown here in 1936, is the only university in the neighborhood. Founded in 1898 by the Vincentians, DePaul is an independent Roman Catholic University that today spreads over 36 acres and educates more than 20,000 students. DePaul is not only the largest private institution in Chicago, it is also the largest Catholic university in America. (Photo courtesy of DePaul University Library Special Collections.)

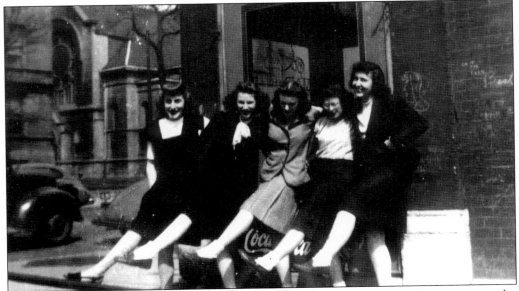

Eddie's Restaurant, located on the southeast corner of Kenmore and Belden, was a popular place for DePaul students to meet and hang out between classes in the 1940s. (Photo courtesy of DePaul University Library Special Collections.)

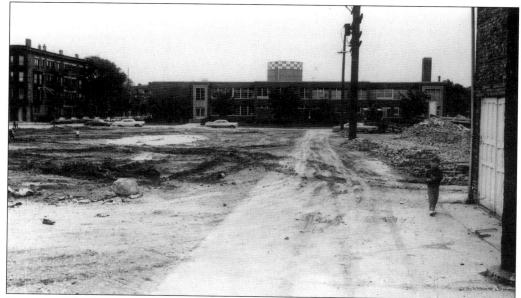

Contractors broke ground and began construction on DePaul University's first residence hall in 1969. Today DePaul has 11 residence halls. (Photo courtesy of DePaul University Library Special Collections.)

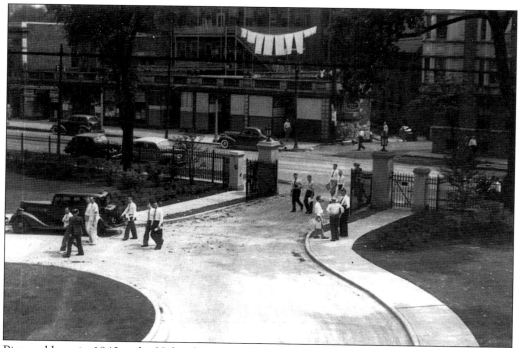

Pictured here in 1940 is the Halsted Street entrance to the McCormick Theological Seminary, which stood at Chalmers Place between Fullerton and Belden. The school was moved from New Albany, Indiana to Lincoln Park in 1857. It remained here until 1975 when it was moved to Hyde Park, one of Chicago's south side neighborhoods. (Photo courtesy of DePaul University Library Special Collections.)

Four

AT WORK

On a warm day, it seems every Lincoln Park resident is outside playing. Everything in Lincoln Park is within walking distance. Grocery stores, pharmacies, movie theatres, restaurants, flower shops, coffeehouses, bookstores, antiques shops, and clothing stores can all be reached without starting the engine of a car. Although one may walk down Clark Street or Lincoln Avenue and find a new business going in at any time, many of the Lincoln Park neighborhood businesses, quite a few of which are family owned and operated, have been around for generations. Some of the neighborhood's businesses are so old they pre-date the Great Chicago Fire. The shopping districts of Lincoln Park have been booming with business for more than 100 years.

But if everyone is out shopping, who is minding the shop…?

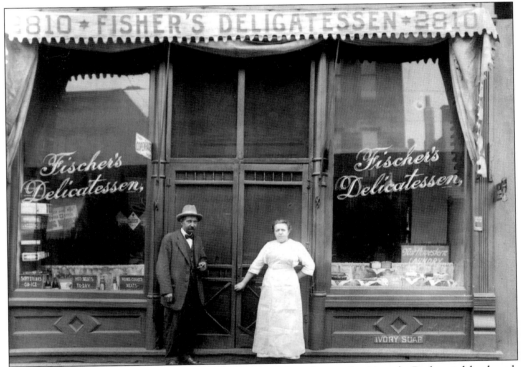

In the late 1800s and early 1900s, hovering just on the edge on the Lincoln Park neighborhood, was Fischer's Delicatessen. Carl Fischer and his wife Emilia were the owners of the deli in the 2800 block of N. Lincoln Avenue. Born in 1868 in Braunschweig, Germany, Carl came to the United States in 1882. In America Carl met and married Emilia Waldman, who was known to her friends and family as Emily. It is interesting to note that although the Fischer name is spelled correctly on the windows of the delicatessen, it is misspelled on the awning. (Photo courtesy of Jennifer Logothetti Gordon.)

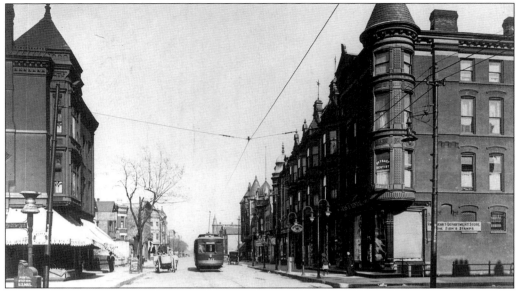

The buildings on the left and some on the right of this 1910 photo were built between 1885 and 1887, and still stand on Bissell Street today. They belong to the owners of Armitage Hardware, 925 W. Armitage. Central Street General Store, whose name was changed in the 1930s to Armitage Hardware in keeping with the street name, opened its doors in 1895. The shops along Armitage Street all have their first floor about 10 feet below the street. When the sewers were laid, the pipes were put down right on the cobblestone road and the street was built up over the pipes. Thus, today's Armitage Street is about 10 feet higher than the Central Street of the late 1800s. (Photo by Charles R. Childs/Courtesy of the Chicago Historical Society.)

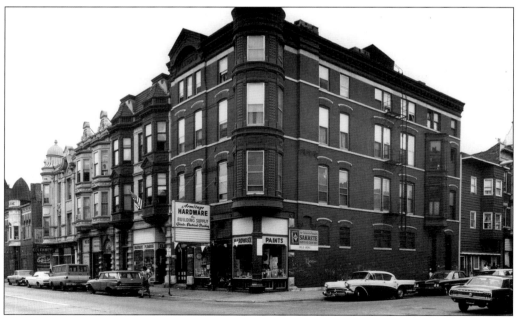

In 1969, Armitage Hardware looked considerably different than it looked 59 years earlier. This is the southeast corner of Armitage and Bissell. (Photo by Sigmund J. Osty/Courtesy of the Chicago Historical Society.)

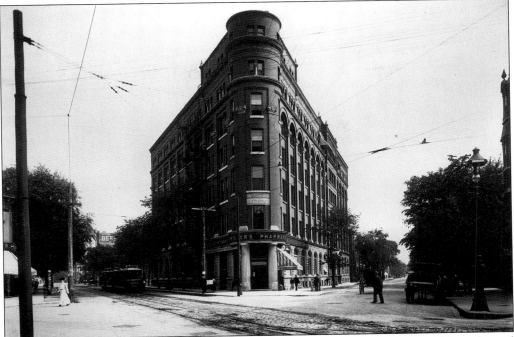

Augustana Hospital once shared space with Miller's Pharmacy at the corner of Lincoln and Garfield. In the 1950s, Herb Braun purchased Miller's Pharmacy and renamed it Braun Drugs. Today Braun Drugs, standing at the southeast corner of Dickens, Cleveland, and Lincoln Avenue is the oldest pharmacy in Lincoln Park, predating the Great Chicago Fire of 1871. (Photo courtesy of the Chicago Historical Society.)

Looking southeast, with Braun Drugs to the right and Carnival Grocery across the street to the left, this is the way the corner of Dickens, Cleveland, and Lincoln Avenue looks today. (Photo by Mindy S. Apel.)

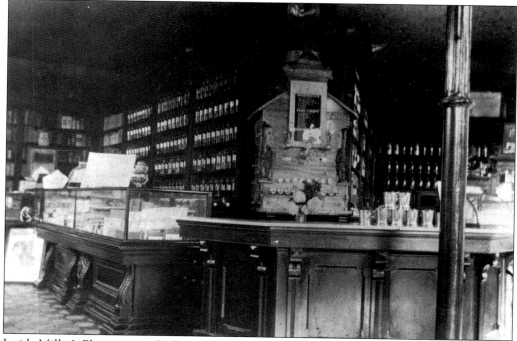

Inside Miller's Pharmacy in the late 1800s, one could enjoy the typical soda fountain specialties of the time. Advertised on the board in the center of the photograph are phosphates and fruit syrups. (Photo courtesy of Braun Drugs/Reproduced by Mindy S. Apel.)

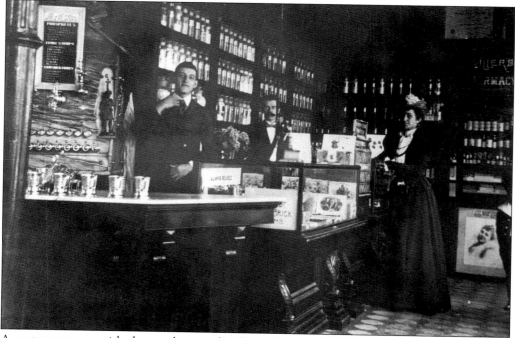

A customer poses with the employees of Miller's Pharmacy in the late 1800s. The small child seen at the far right edge of the photo is the little boy pictured with his sister on the cover of this book. (Photo courtesy of Braun Drugs/Reproduced by Mindy S. Apel.)

At the northwest corner of what is now the intersection of Dickens, Cleveland, and Lincoln Avenues, the Presidents Hotel once stood in the space that is now occupied by a fountain and a few benches. To the right of the hotel, pictured here, one can see the building that is now Carnival Grocery. This corner was at one time referred to as the Presidents' Corner because of the names of the streets, Garfield (now Dickens), Lincoln, and Cleveland. (Photo courtesy of Braun Drugs/Reproduced by Mindy S. Apel.)

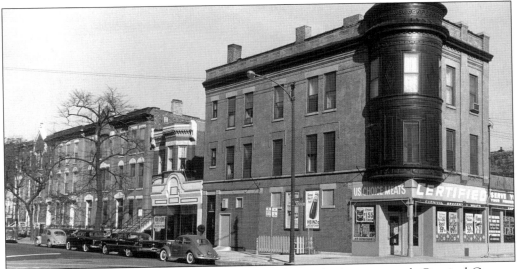

At the northeast corner of Cleveland, Dickens, and Lincoln Avenue stands Carnival Grocery Store, opened in 1937. Sigmund J. Osty took this photo in 1963. Purchased sometime between 1949 and 1952 by George Costas and his father-in-law Harry Andrew Dimopoulos, the original store occupied only the very front section of the building. In 1959, Costas bought out Dimopoulos. Ten years later, Costas bought out the entire space and the store became as it is today. In 1968, Dimopoulous' grandson, also named Harry, came to work at Carnival Grocery. By 1982, he was the primary owner of Carnival Grocery. Four years after Costas' death in April 1997 at age 77, Arthur Paris purchased it from the family corporation. Shortly after this photo was taken, reknown dance teacher Berenice Holmes opened her storefront ballet school in the small building to the left. Young Lincoln Park girls danced there for years, even after Miss Holmes' death in April 1982 at age 77. Today a dry cleaner occupies the building. (Photo courtesy of the Chicago Historical Society.)

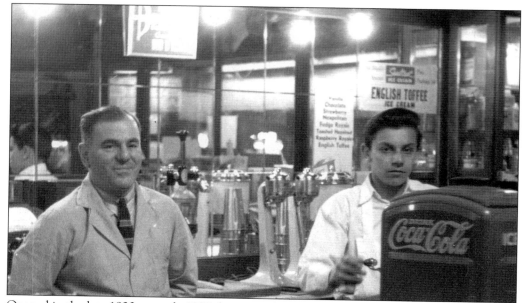

Opened in the late 1920s or early 1930s by owner Oscar Gordon, Gordon's Cut Rate Drugs stood on the northwest corner of Clark and Deming until 1957. Today an Einstein Bros. Bagels occupies the building. A full-service soda fountain complete with a grill and counter seating, typical of the era, kept customers coming back for more than just toiletries and cigarettes. Gordon and his brother owned two other drug stores with the same name. All three drug stores were on Clark Street in Lincoln Park. One was at the northwest corner of Clark and Arlington and another was at the southeast corner of Clark and Wrightwood. (Photo courtesy of Lois Gordon Golub.)

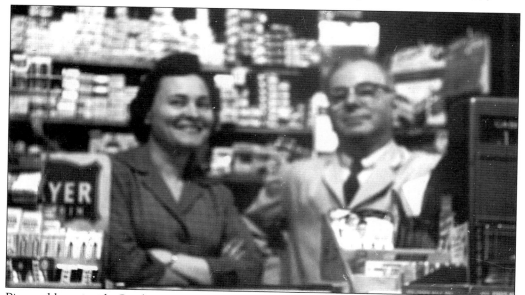

Pictured here inside Gordon's Cut Rate Drugs are Oscar Gordon and his young wife Helen. In the 1940s, Oscar and Helen Gordon raised three children, Robert, Lois, and Kenneth, in an apartment above their drug store. They sold their shop in 1957. Adjacent to Gordon's Cut Rate Drugs was an empty lot where Christmas trees were sold during the holiday season. (Photos courtesy of Lois Gordon Golub.)

In 1925, Henry Fischer stands in front of the original Fischer's Flowers, owned by his father, at 2040 N. Cleveland Avenue. The Fischer Family lived in four rooms behind the shop from 1925 until 1931. (Photo courtesy of Joan Fischer Stowell.)

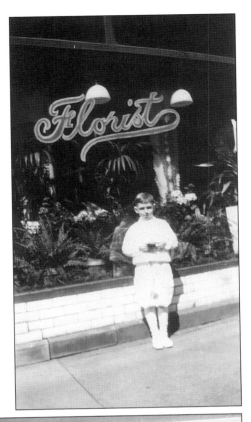

Flowers were in full bloom at Fischer's Flowers in July 1947. William Fischer, who owned the flower shop at the corner of Dickens and Sedgwick, prepared flower arrangements for Lincoln Park weddings, funerals, and other special events. Beside the patriarch of the Fischer family are William's son Henry "Hank" Fischer, who took over this location when his father died in 1966, and Hank's little daughter Joan. (Photo courtesy of Joan Fischer Stowell.)

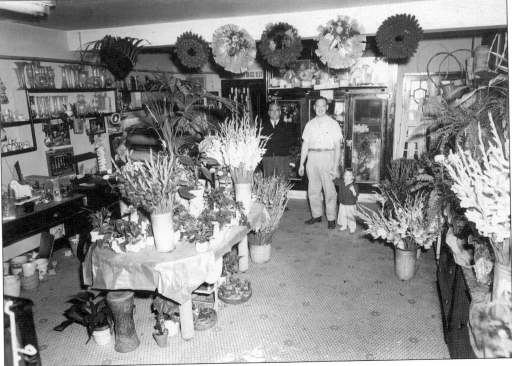

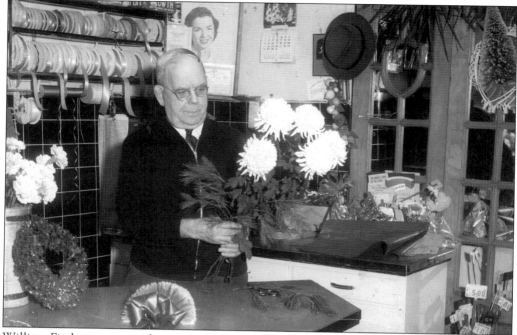

William Fischer prepares a bouquet of flowers in his shop in the early 1960s. Before owning his own flower shop, William worked as an apprentice in Germany for three years and then worked in greenhouses here in America. (Photo courtesy of Joan Fischer Stowell.)

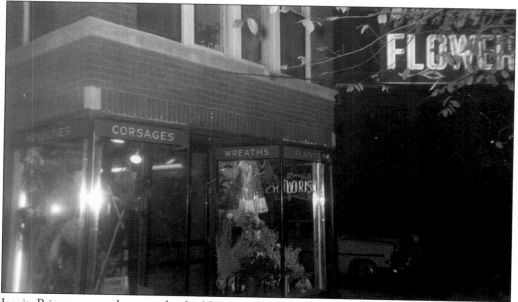

Jesuit Priests currently own the building standing at the southeast corner of Dickens and Sedgwick. For many years until the early 1970s, however, the building was one of several owned by the Fischer family. It was purchased by William and Anna Fischer for $4,000 in 1942 after they had lived in the building for 11 years paying just $40 per month in rent. Three generations of Fischers owned and worked in the neighborhood's well-known flower shop, Fischer's Flowers. (Photo courtesy of Joan Fischer Stowell.)

In February 1950, August Logothetti (right), a Chicago police officer whose beat was Lincoln Park and the Lincoln Park Zoo, posed with his partner in front of their squad car. However, according to his family, legend has it that August usually patrolled his beat riding a three-wheeled Harley. (Photo courtesy of Jennifer Logothetti Gordon.)

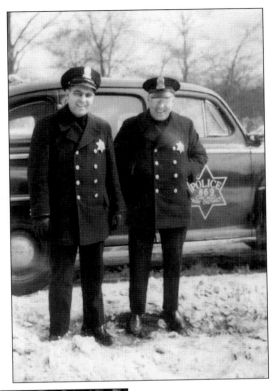

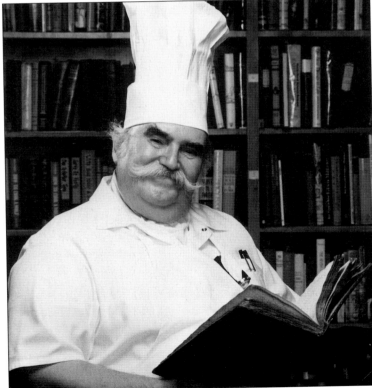

Hungarian-born Chef Louis Szathmary opened The Bakery Restaurant on Lincoln Avenue in 1962. The restaurant occupied 2214–2218 N. Lincoln until 1989. A street just off Webster behind the restaurant was named for Chef Szathmary, who died in 1993 at the age of 74. (Photo courtesy of Bob Swanson.)

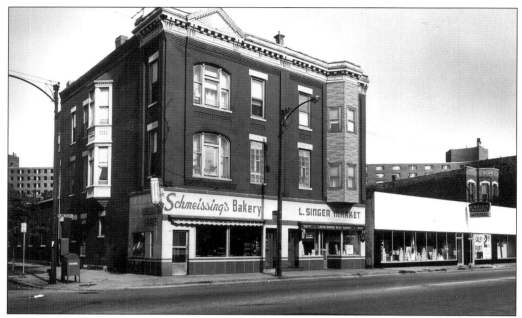

Schmeissing's Bakery bakes some of the best cakes in Lincoln Park. Located on Lincoln Avenue at the southeast corner of Seminary just south of Diversey, Schmeissing's has been a family-run business since 1934. This September 1968 photo by Sigmund J. Osty shows a relatively bare view of Lincoln Avenue. The meat market and paint store are long gone, having been replaced by a coffee café in 1975, and condos. (Photo courtesy of the Chicago Historical Society.)

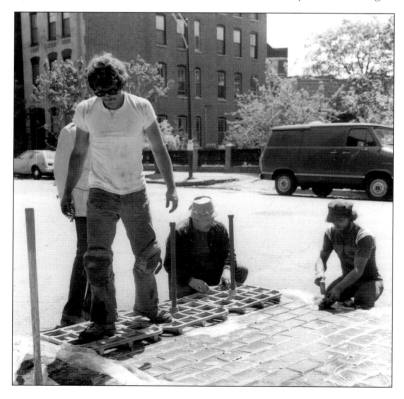

Neighborhood maintenance and beautification have always been a priority in Lincoln Park. In the 1970s, workers toiled laying bricks, pouring cement, and planting trees to make the walk down the 2200 block of Geneva Terrace a lovely visual experience. (Photo courtesy of Mrs. Norman Barry.)

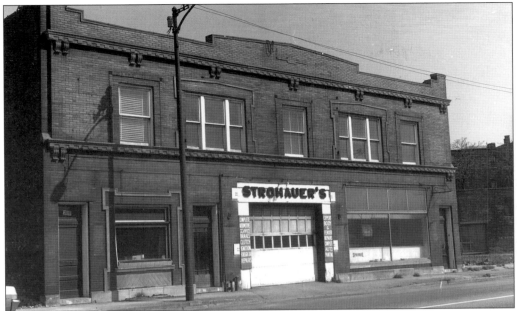

John and Georgia Strohauer's Garage stood on Lincoln Avenue between Cleveland, Geneva Terrace, and Webster before it was replaced in the 1970s by townhouses. (Photo courtesy of Mrs. Norman Barry.)

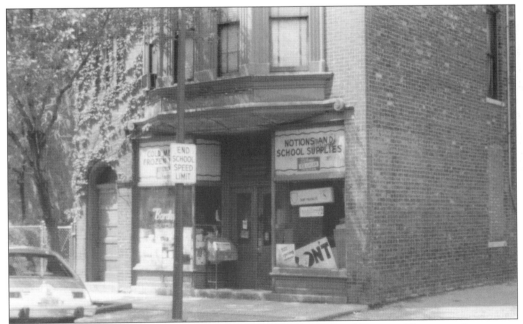

At the alley on the block of Geneva Terrace between Belden and Kemper Place was, for years, a small shop known by many as The School Store. Just around the corner from Lincoln Elementary School, the small store, run by sisters Esther and Lill, sold candy and school supplies by day and grocery essentials during the hours when school was not in session. Also known as the Little Store, Esther and Lill opened their doors in 1945, while still young mothers. The School Store finally closed its doors for good in 1987. (Photo courtesy of Nancy Stocking/ Lincoln School.)

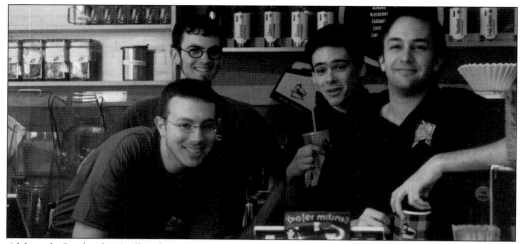

Although Starbucks Coffee decorates nearly every other corner of Lincoln Park, there are other neighborhood coffee options as well. Caribou Coffee, a tiny shop with a warm ambiance, located at 2453 N. Clark, occupies just one of seven store fronts on the ground floor of a 1920s building that stretches for an entire block from Arlington to Roslyn Street. The spot occupied by Caribou Coffee was once the famous Frances' Deli. However, Mr. Submarine occupied the spot when current owners purchased the building in the mid-1990s. On a scorching Saturday in June 2002, coffeemakers (from left to right) Robert Gallagher, Benjamin Mumford, Ben Stewart, and their manager, Doug Brandt, have a blast making great coffee for their customers. One of the first Caribous in the area, this shop has been open since 1997. (Photo by Mindy S. Apel.)

Restaurateurs Rich Melman and Jerry Orzoff opened the doors to RJ Grunt's on June 10, 1971. Named R for Rich, J for Jerry, and "grunt!" for the sound made when eating one of their delicious burgers, today this bustling restaurant, located on the southwest corner of Dickens and Lincoln Park West, is a Lincoln Park landmark of its own kind. Boasting a menu to please just about everyone, RJ Grunt's claims to have invented the concept of the salad bar. Whether or not this is true, one thing is certain: RJ Grunt's Temperature Soup is a cup of soup sold for the price of the lakefront temperature. The walls of the restaurant are covered with photos of former "Grunt Girls." In 1997, when Rich Melman decided to close down RJ Grunt's, Lincoln Park residents objected and Melman kept his place open. Dori Geil (left) has been a "Grunt Girl" for 17 years. Manager Sandra Holloway has been keeping the restaurant running smoothly for the past two years. (Photo by Mindy S. Apel.)

Five

THE HOUSE
OF WORSHIP

No neighborhood would be complete without a house of worship. Lincoln Park has so many churches it is nearly impossible to count them all. From small, unimposing structures providing cozy worship to grandiose sanctuaries in which neighbors congregate to worship as well as socialize, Lincoln Park has a church for nearly everyone and sometimes more than one on a single block. Among some of the oldest historical establishments in the neighborhood, the vast number of churches in the neighborhood could fill a book of their own.

Their buildings are beautiful and their legacies are enduring...

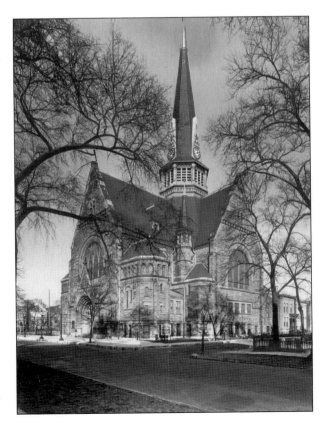

St. Pauls United Church of Christ was originally called the German Evangelical Lutheran St. Pauls Congregation. Of interesting note is the fact that there is no apostrophe in the word "Pauls." This is because the name of the church was translated from the German language, which does not use the apostrophe. Nine German immigrants from Prussia and their wives founded the congregation in 1843. In 1855, the congregation outgrew its original building, one room with a coal stove, located at LaSalle and Ohio Streets. The Chicago Fire of 1871 destroyed their new building. The congregation moved to Lincoln Park in 1898. This photo shows the original 1898 building, which stood at the corner of Orchard and Kemper Streets until 1955. (Photo courtesy of St. Pauls United Church of Christ Archive.)

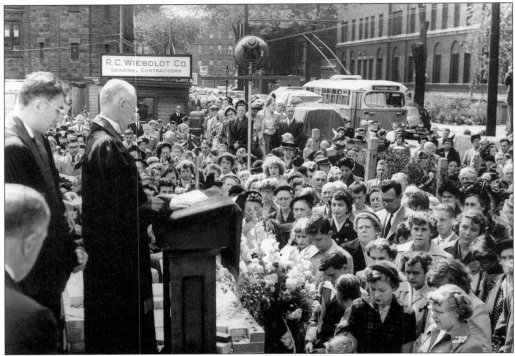

In 1951, neighbors and parishioners gathered for a ceremony dedicating the laying of the cornerstone for the St. Pauls United Church of Christ's new parish house at 2335 North Orchard Street. R.C. Wieboldt, son of William Wieboldt, church member and department store founder, was the general contractor on the project. In the background, the #74 Fullerton trolley car passes heading north on Orchard Street, alongside Children's Memorial Hospital. (Photo courtesy of St. Pauls United Church of Christ Archive.)

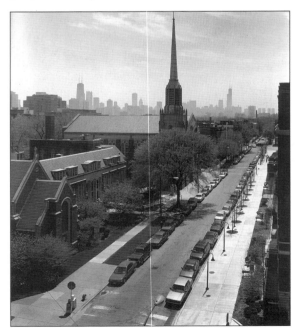

This photo of St. Pauls United Church of Christ looking south down Orchard Street from Fullerton shows the fifth church building as it looks today. Children's Memorial Hospital borders the photo on the right side. Both the John Hancock Building and the Sears Tower can be seen in the background along Chicago's downtown skyline. (Photo courtesy of St. Pauls United Church of Christ Archive.)

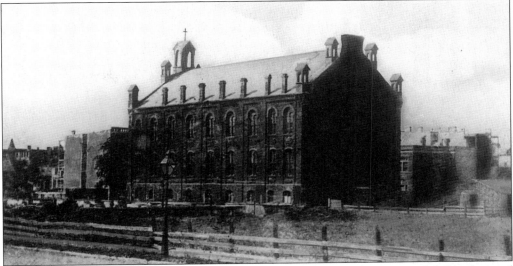

In 1898, St. Vincent's Church, as seen here from Sheffield Avenue, was remodeled and turned into classrooms. The building reopened as St. Vincent's College, and nine years later it became DePaul University. (Photo courtesy of DePaul University Library Special Collections.)

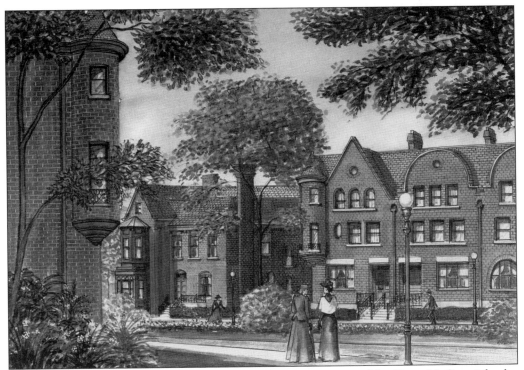

All that remains of the McCormick Theological Seminary—named for Cyrus McCormick who donated a generous $100,000 to the seminary—at Chalmers Place between Fullerton and Belden are the 18 McCormick rowhouses, which are now privately owned. However, because of their historical significance to the neighborhood, the houses were designated part of Chicago's historical district landmarks in 1977. This painting by George Yelich depicts McCormick Theological Seminary in 1905. (Photo courtesy of Mrs. Norman Barry.)

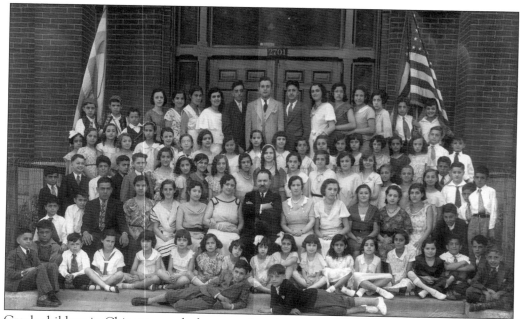

Greek children in Chicago spend afternoons learning about their native culture at St. George Greek Orthodox Church's Greek School. Grades one through six learn to speak, read, and write their families' native Greek. St. George Greek Orthodox Church, at 2701 North Sheffield just south of Diversey, has been a center of Greek-American culture since a group of Greek immigrants purchased and adapted a Lutheran Church in March 1923. This group of Greek School students posed outside the church with the Very Reverend Archimandrite Daniel Golemis (a native of Sparta), and the teachers of the Greek School in 1932. (Photo courtesy of St. George Greek Orthodox Church.)

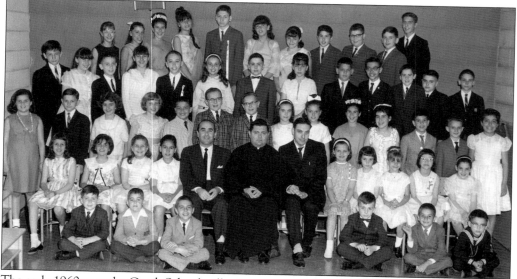

The early 1960s saw the Greek School still going strong, with students studying both the language and religion of their culture. The pretty little girl named Athena Kalady, pictured third from the right in the second row, now works in the Church Administrative Offices. Athena's older sister is pictured in the back row, first on the left. (Photo courtesy of St. George Greek Orthodox Church.)

Many Lincoln Park neighbors remember the controversy over Grace Lutheran Church at the southeast corner of Geneva Terrace and Belden. The building seen just to the left of the church was at one time its parish house. In the mid-1970s, following the 1975 departure of the church's pastor, Rev. Philip Bigelow, the church building opened it doors to all sorts of different venues that left the neighbors less than pleased. A rental to Facets Multimedia that had moviegoers in the building late at night; housing 80 teenage girls for Chrysalis Alternative High School; church rentals causing parking difficulties on the street; lack of building maintenance, and a number of other complaints against the church caused the church to be sued by the City of Chicago in the 1970s for a breach of zoning regulations. (Photo courtesy of Mrs. Norman Barry.)

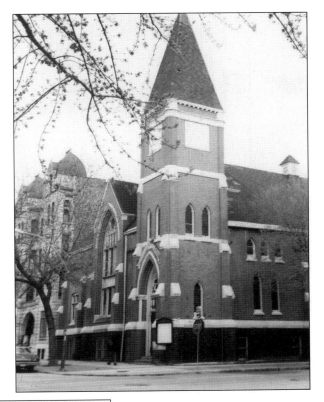

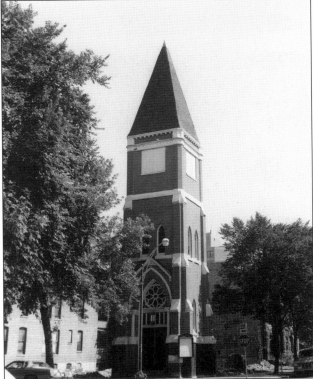

By late 1976, the owners of Grace Lutheran Church buckled under the pressure from their neighbors. Feeling unable to maintain the church building without tenants, they authorized the sale of the building. In 1978, the Mid-North Association held an auction of everything left in the church, from the pews and stained glass windows to the radiators sold for scrap metal. After the demolition of the controversial church, all that remained of Grace Lutheran was the bell tower. Today, the bell tower makes an interesting cornerstone of a row of townhouses that stretch south on Geneva Terrace. (Photo courtesy of Mrs. Norman Barry.)

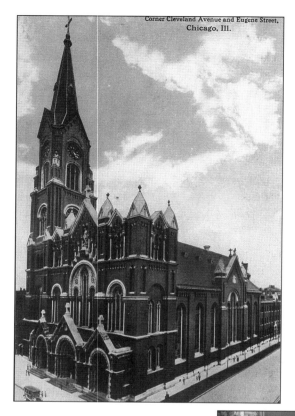

German Catholics were brought together in 1852 by Redemptorists Rev. Anthony Copp and Michael Diversey to create St. Michael's Catholic Church. The neo-gothic brick building, located at 455 W. Eugenie, remained the tallest building in Chicago from the time it was built in 1869 until 1885. St. Michael's Church stood in the path of the Great Chicago Fire. However, the solid brick construction saved the structure from major damage. The inside of the church was restored in 1872. The church is still considered the tallest church in Chicago. (Postcard courtesy of DePaul University Library Special Collections.)

In August of 1992, Lincoln Park resident Jennifer Costin married Scott Thomas in a beautiful ceremony in the grand sanctuary of St. Michael's Church. Pictured here are Father Oldershaw, Father Gino Donatelli, the bride and groom, maid of honor Leigh Uttich, and best man Brooks Thomas. (Photo courtesy of Jennifer Costin Thomas.)

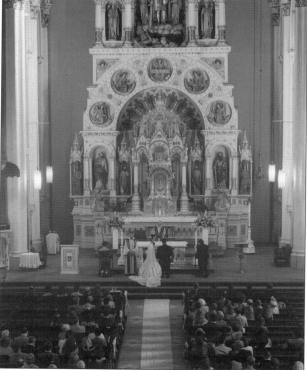

In 1905, a group of predominantly German men and women requested a German-speaking parish in Lincoln Park. Father Francis A. Rempe left his post at St. Benedict's Church in Blue Island, and for the next 41 years, he was pastor of the new Lincoln Park parish called St. Clement's. Father Rempe stayed in the home of the A.J. Kasper family at 628 Deming Place for several months following his arrival. The first Sunday service of the new St. Clement's Parish was held on August 6, 1905 in the Alcott School on Wrightwood. There were two sermons that day, one in English and one in German, to meet the needs of neighbors. By September, the parish had acquired two large pieces of land at Deming and Orchard. (Photo courtesy of St. Clement's Church.)

Providing a traditional good Catholic education to neighborhood children is the St. Clement's School, which is just across Orchard Street to the west of St. Clement's Church. With 85 students, the school opened its doors in September of 1906. The school was adjacent to the St. Clement's Convent. In 1925 and 1926, the school was renovated to include the current cafeteria, gym, and third floor. (Photo courtesy of St. Clement's Church.)

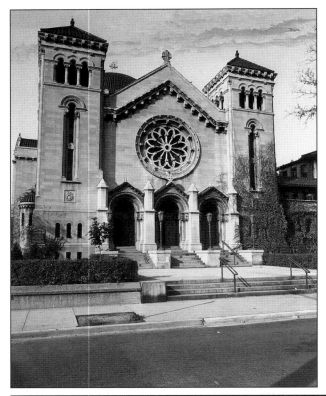

This is the current St. Clement's Church at 642 W. Deming Place, which was built between 1917 and 1918. The somewhat ornate architecture is reminiscent of the Byzantine style. (Photo courtesy of St. Clement's Church.)

St. Clement's Church Altar Boys were photographed for the Silver Jubilee book that the church put together for its 25th anniversary celebration in 1930. (Photo courtesy of St. Clement's Church.)

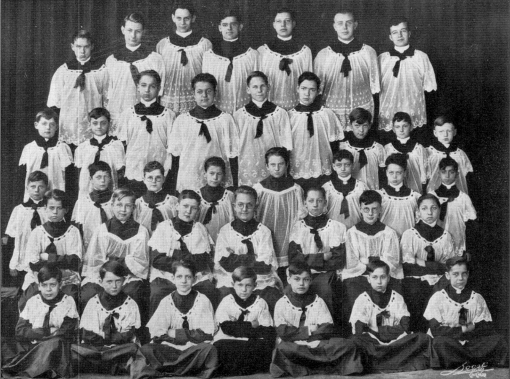

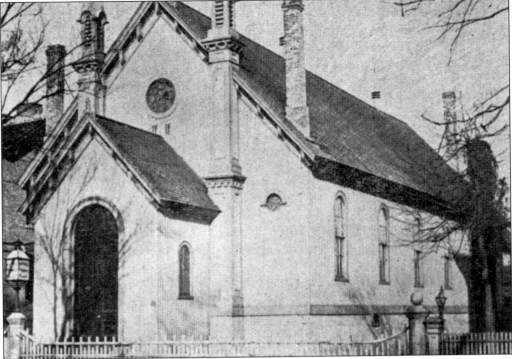

In 1864, Dr. Willis Lord, a McCormick Theological Seminary professor, organized the Fullerton Avenue Presbyterian Church, seen in this photo. The church building was located at 530 W. Fullerton. At this time, much of Clark Street, known as Green Bay Road, straight across to Halsted Street consisted of pasture and cattle grazed openly. Additions were made to the building in both 1866 and 1870. By a stroke of good fortune, the Great Chicago Fire of 1871 stopped just before it would have taken down the church. This photo was taken sometime before 1888 when the church ceased use of this building and it was sold to Church of Our Saviour (Episcopal). (Photo courtesy of Barry Smith/Lincoln Park Presbyterian Church.)

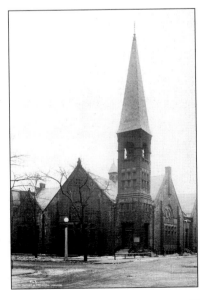

This c. 1920 photo shows the second building in which the Fullerton Avenue Presbyterian Church congregation worshipped. It was designed by architect John S. Woollacott and built of Michigan buff sandstone in the Romanesque style. In 1898, architect William G. Barfield designed a 25-foot addition to the west side of the building, located at the northwest corner of Fullerton and Geneva. The congregation merged with Church of the Covenant (Presbyterian) in 1932 to become the Fullerton-Covenant Presbyterian Church. The name was shortened to simply the Fullerton Presbyterian Church in 1961. Five years later the Fullerton Presbyterian Church merged with Christ Church (Presbyterian) to form the Lincoln Park Presbyterian Church, making its home at 600 W. Fullerton, where it remains. The building was constructed in 1888. This photo shows the building as it looks today, except for the steeple, which was removed in 1970 because of falling tiles. (Photo courtesy of Barry Smith/Lincoln Park Presbyterian Church.)

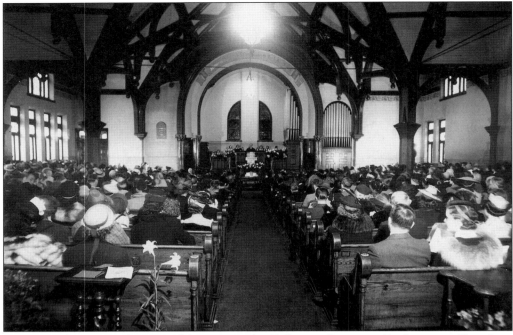

Easter Sunday was a glorious celebration at the Fullerton-Covenant Presbyterian Church in 1939. This photo is the earliest known photo of the interior of the church, which is now home to the Lincoln Park Presbyterian Church. (Photo courtesy of Barry Smith/Lincoln Park Presbyterian Church.)

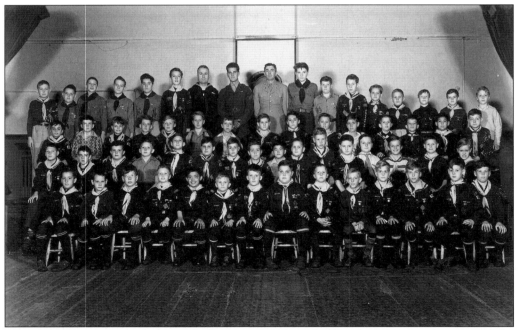

This Boy Scout Troop, photographed in 1945, met in the Sunday school auditorium of the Fullerton-Covenant Presbyterian Church, now the Lincoln Park Presbyterian Church. (Photo courtesy of Barry Smith/Lincoln Park Presbyterian Church.)

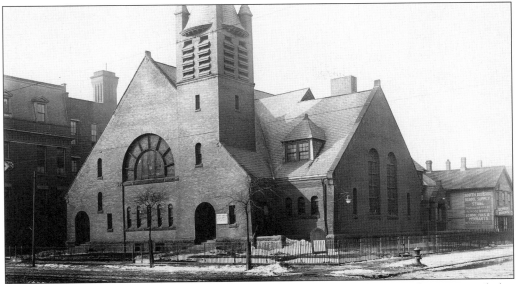

Christ Church (Presbyterian) was the official name of the congregation that occupied this building, which was located on the northwest corner of Armitage and Orchard. This photo dates back to approximately 1920. The congregation was a successor to several neighborhood mission Sabbath schools, one of which dates as far back as 1843, that were founded by Second Presbyterian, Fourth Presbyterian, and the McCormick Theological Seminary. Christ Church became a full-fledged independent church in 1900. Sixty-six years later it merged with the Fullerton Presbyterian Church to form the Lincoln Park Presbyterian Church. Because of this merger, the Lincoln Park Presbyterian Church enjoys status as the third oldest Presbyterian institution in Chicago. A year after the merger took place the church was purchased by the Board of Education and torn down to make space for a school building parking lot. (Photo courtesy of Barry Smith/Lincoln Park Presbyterian Church.)

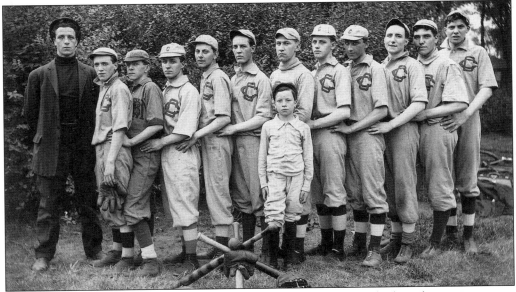

This is the Christ Church Baseball Team, c. 1910. Perhaps the team had just lost an important game. Such serious faces! (Photo courtesy of Barry Smith/Lincoln Park Presbyterian Church.)

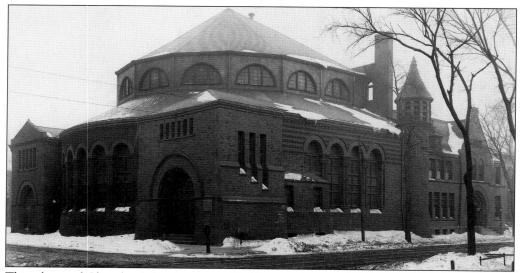

This photo of Church of the Covenant (Presbyterian) was taken around 1920. Dr. Thomas Skinner of the McCormick Theological Seminary founded the congregation in 1885. Designed by architects Burnham and Root, the chapel was erected the same year and the main building followed three years later. The congregation merged with Fullerton Avenue Presbyterian Church in 1932. The building itself was sold to St. John's Assyrian Church and then torn down in 1965. Located at the southeast corner of Halsted and Belden, this site is now occupied by a Children's Memorial Hospital administration building. (Photo courtesy of Barry Smith/Lincoln Park Presbyterian Church.)

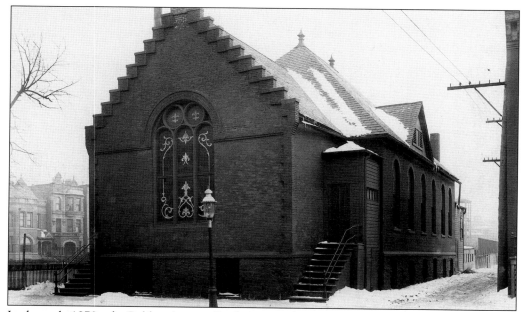

In the early 1870s, the Belden Avenue Presbyterian Church, seen in this 1920 photo, was started up by the Fullerton Avenue Presbyterian Church and originally called the Nickersonville Mission. By 1883 the church had become independent, and a year later this building was constructed at Belden and Seminary. The congregation no longer exists and the date of its closure is unknown. (Photo courtesy of Barry Smith/Lincoln Park Presbyterian Church.)

Six

CARING FOR THE SICK

From humble beginnings in small neighborhood houses to "Best of..." ratings, Lincoln Park's hospitals have cared for sick neighbors, both young and old, with love and dedication since the mid-1800s. Most of the neighborhood's hospitals have been torn down, but those that remain have undergone expansions and improvements to meet the needs of and keep up with the growing neighborhood.

Today Lincoln Park has only two hospitals, but there was a time when it seemed there was a hospital at the end of almost every major block...

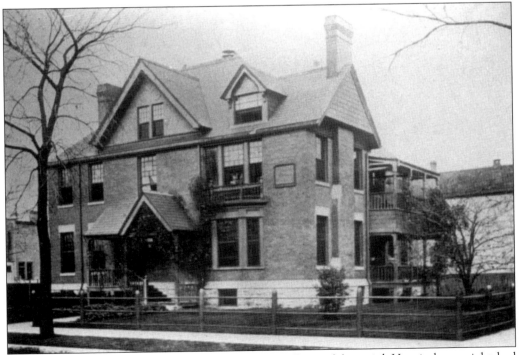

In 1882, Mrs. Julia F. Porter opened the Maurice Porter Memorial Hospital, an eight-bed cottage, in this house at Belden and Halsted, in memory of her 13-year-old son Maurice. (Photo courtesy of Children's Memorial Hospital.)

Mrs. Porter's goal was to provide sick neighborhood children with free medical care. The original hospital soon saw local demand outweigh available space. Today, the hospital, known as Children's Memorial, has been rated one of the top children's hospitals in the state of Illinois. It is the only strictly children's hospital in the Chicago area. (Photo courtesy of Children's Memorial Hospital.)

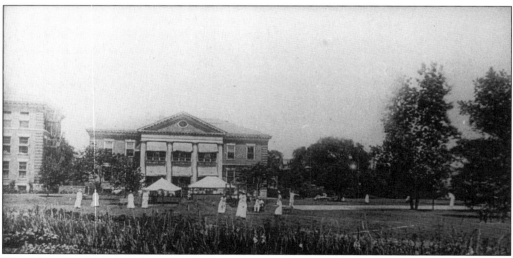

This photograph shows the Children's Memorial Hospital grounds c. 1913. As the hospital gained reputation, it outgrew its original space. Mrs. Porter made plans for construction of a larger hospital at Lincoln Avenue and Orchard. The new building made room for 20 more beds. By 1890, the hospital had a staff of six, beds for 68 children, and a reputation for excellent complete care of both children and their families. Eventually the name of the Maurice Porter Memorial Hospital was changed to Children's Memorial Hospital. (Photo courtesy of Children's Memorial Hospital.)

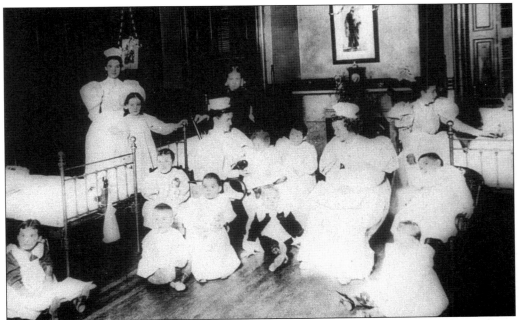

This photo of several nurses and their pint-sized patients at Children's Memorial Hospital was taken around 1890 in the original Maurice Porter Hospital building. (Photo courtesy of Children's Memorial Hospital.)

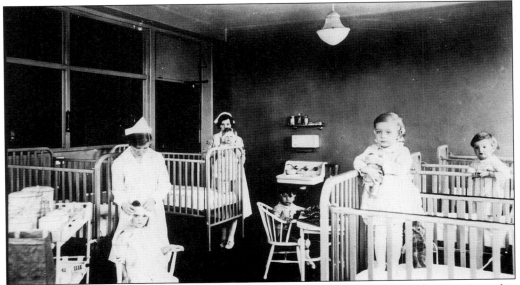

Children's Memorial Hospital has undergone many physical and structural changes since this 1933 photo. What remains the same are the dedication and care given to its young patients, whether they are in for a tonsillectomy or a long-term, chronic illness such as cystic fibrosis. (Photo courtesy of Children's Memorial Hospital.)

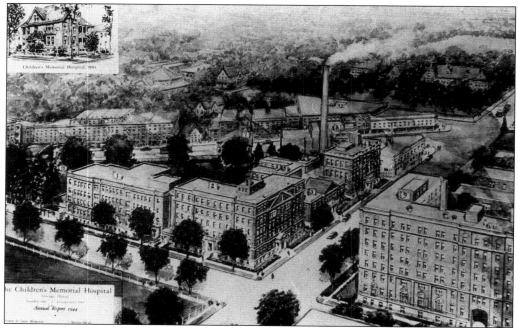

This image shows the grounds of Children's Memorial Hospital in a 1944 Annual Report. The building on the left of Fullerton Avenue is the current hospital. The street to the rear of that building, near the smokestack, is Lincoln Avenue. The building on the right was at one time the main hospital and now houses offices, the hospital's library, Occupational Health, the psychiatric facility, and rooms for resident doctors. (Photo courtesy of Children's Memorial Hospital.)

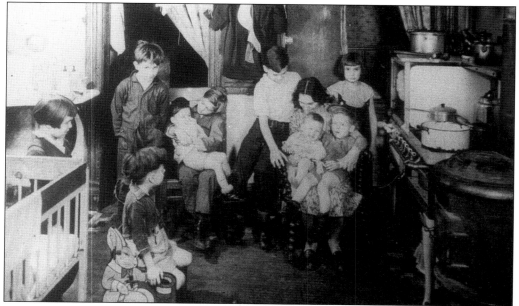

This undated photo from Children's Memorial Hospital's archives is marked with the caption, "Another Clinic Family." On close inspection, the photo appears to have been taken inside the home of the family, rather than in the hospital itself. (Photo courtesy of Children's Memorial Hospital.)

The first building to house the German Hospital, known since 1918 as Grant Hospital, was a residence at 2225 North Lincoln Avenue. The year was 1883 and the city had recovered from the Chicago Fire of 1871. Thousands of German immigrants had come to Chicago and many made the Lincoln Park neighborhood their home. The first year it was open, the German Hospital cared for 25 patients. This photo was taken in 1887, a year when outbreaks of smallpox, influenza, diphtheria, and typhoid necessitated larger hospitals with better equipment. The German Hospital moved to a new brick building. By 1896, again more space was needed and a fireproof annex and nurses' training school were added. A residence for nurses was opened on Webster in 1925. (Photo courtesy of Grant Hospital/Reproduced by Mindy S. Apel.)

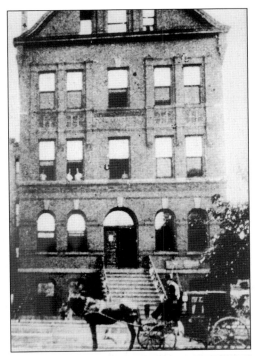

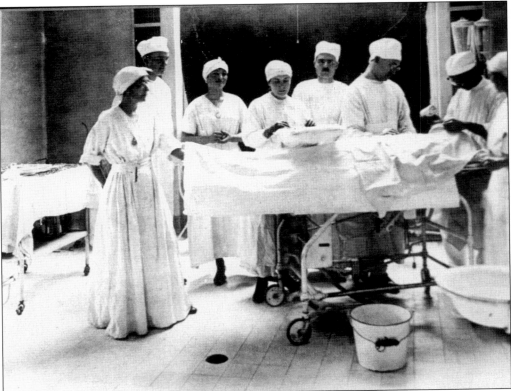

The operating room of the early 1900s, as seen at German Hospital, was considerably different from that of today. (Photo courtesy of Grant Hospital/Reproduced by Mindy S. Apel.)

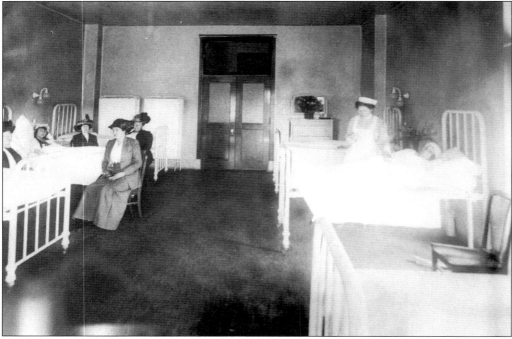

Anyone who has visited a modern day Intensive Care Unit can appreciate the changes that have taken place since this 1920s photograph of the ICU in Grant Hospital's 1912 building. (Photo courtesy of Grant Hospital/Reproduced by Mindy S. Apel.)

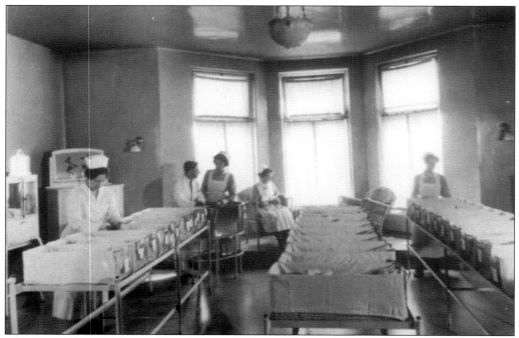

The German Hospital opened an infant welfare clinic in 1920. Always interested in giving the best care to babies, a premature baby station was opened in 1956. This is a 1934 photo of Grant Hospital's nursery. (Photo courtesy of Grant Hospital/Reproduced by Mindy S. Apel.)

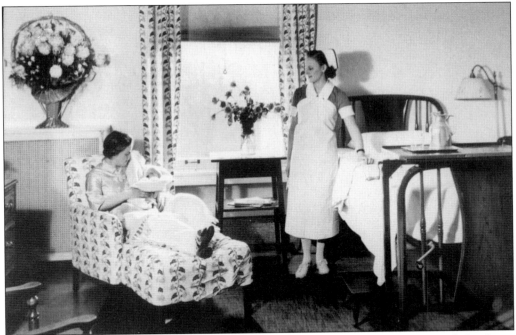

This 1937 photo of a nurse attending to the needs of a mother and her newborn baby shows one of Grant Hospital's comparatively luxurious maternity rooms. (Photo courtesy of Grant Hospital/Reproduced by Mindy S. Apel.)

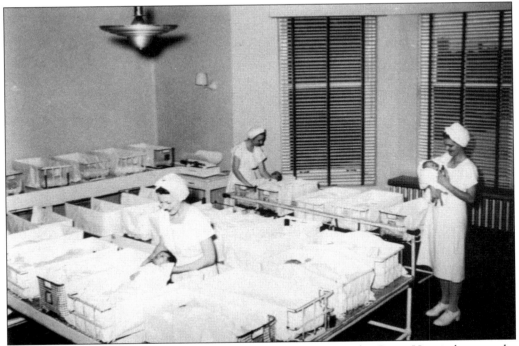

Although the room was the same, subtle changes can be seen in the Grant Hospital nursery by the time this January 1946 photo was taken. (Photo courtesy of Grant Hospital/Reproduced by Mindy S. Apel.)

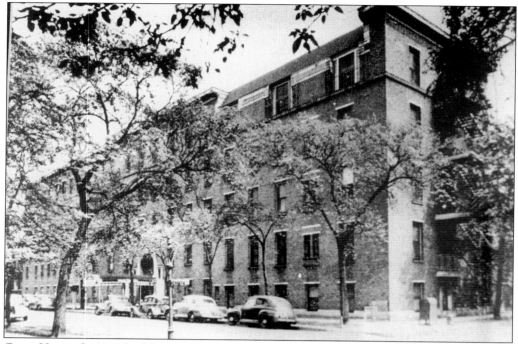

Grant Hospital's 1912 building looked like this around 1950. This entrance, which faced Grant Place, was later closed in favor of the current Webster entrance. (Photo courtesy of Grant Hospital/Reproduced by Mindy S. Apel.)

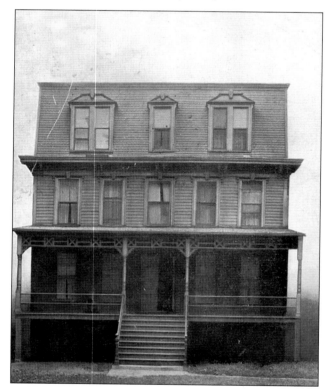

This 1884 photograph shows Augustana Hospital's original building. The hospital would eventually span an entire block of Dickens Avenue from Sedgwick to Lincoln Avenue. Known as a nice neighborhood hospital, generations of Lincoln Park residents were born there and found it a nice place to work as well. In 1987, Lutheran General Hospital purchased Augustana Hospital. Extensive remodeling included creation of a beautiful birthing center and relocation of the entrance and main lobby from Dickens to Lincoln Avenue. Immediately following the remodeling, the hospital was torn down and townhouses were built on the land. With the demolition of the hospital, many families lost their jobs. (Photo courtesy of Nancy Stocking/Lincoln School.)

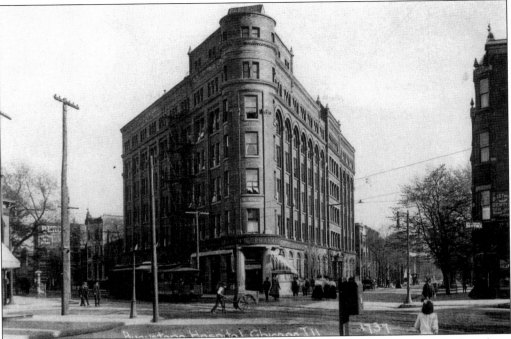

Augustana Hospital, pictured here in 1908, took up a full city block from Sedgwick to Cleveland on Garfield, now Dickens Avenue. There is vague recollection by some Lincoln Park neighbors that this land may have been a brewery at one time. Augustana Hospital shared space with Miller's Pharmacy. (Photo courtesy of the Chicago Historical Society.)

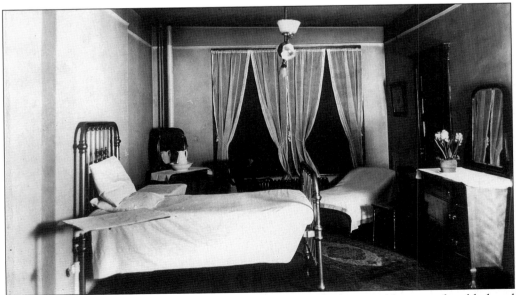

The Augustana Hospital patient room in this 1910 photo looks more like a comfortable hotel room than hospital quarters. More than 70 years later, rooms similar in comfort level were added to the maternity wing for the comfort of mothers giving birth. Just after the beautiful addition was made by the Lutheran General Hospital takeover, the hospital was razed. (Photo courtesy of the Chicago Historical Society.)

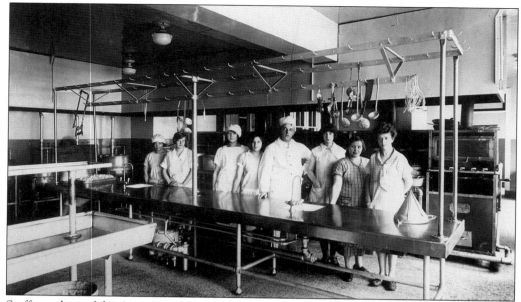

Staff members of the Augustana Hospital kitchen are pictured here around 1920. The hospital's gift shop had a small snack shop inside, just off to the right. Visitors could come in for a sandwich or a cup of coffee. Others took lunch in the snack shop. It would not be uncommon to see the neighborhood mailman sitting at the counter dining among other neighbors. (Photo courtesy of the Chicago Historical Society.)

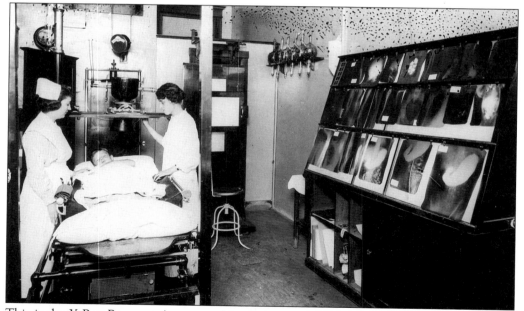

This is the X-Ray Room at Augustana Hospital around 1920. Many years later, one Lincoln Park neighbor and former Augustana Hospital employee recalls a large neighborhood dog ,who came into the hospital to get radiation treatment for cancer several evenings a week after the daytime hustle and bustle died down. The dog would be seen walking in and then some time later he would be seen wheeled out in a wheelchair. The hospital was known for serving its neighbors well. (Photo courtesy of the Chicago Historical Society.)

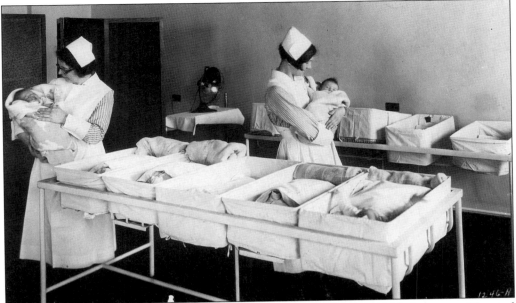

Nurses care for newborn babies in the Augustana Hospital nursery, *c*. 1926. Augustana Hospital had its own School of Nursing on site, complete with a residence hall and a pool in the basement of the building. (Photo courtesy of the Chicago Historical Society.)

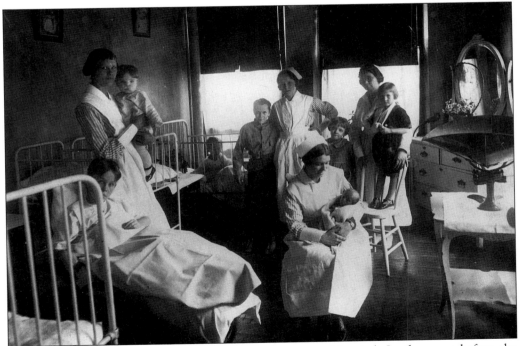

Small children were always well cared for at Augustana Hospital. In the years before the hospital met its ultimate demise, children were infrequent patients, due to Children's Memorial Hospital, just a few blocks north. Thus, when a child was admitted to Augustana, he or she was given the royal treatment by the nursing staff, as it was such a rare treat for them to have a child to care for. (Photo courtesy of the Chicago Historical Society.)

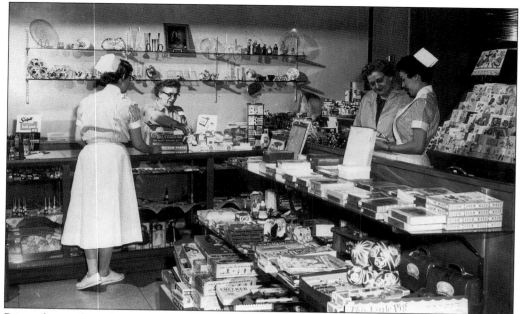

Primarily run by volunteers, the Augustana Hospital gift shop, shown here in the 1950s, was popular not only to patients and visitors but to Lincoln Park residents as well. A short time before Lutheran General Hospital took over Augustana Hospital, the hospital entrance was moved from Dickens to Lincoln Avenue. The gift shop shown in this hospital photo was closed and a new gift shop was opened alongside the new entrance. (Photo courtesy of the Chicago Historical Society.)

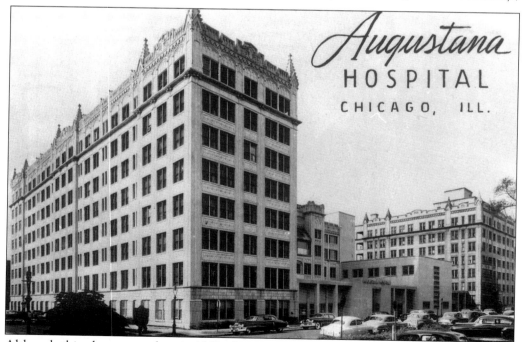

Although this photo was taken in 1960, this is roughly the look of Augustana Hospital in its final years. This is the southwest corner of Dickens and Sedgwick. (Photo courtesy of DePaul University Library Special Collections.)

Seven

MONUMENTS AND MUSEUMS, STATUES AND FOUNTAINS

Standing proud in the green grass of Lincoln Park are more than twenty statues, fountains, and monuments memorializing famous and important people and events. Between 1880 and 1900 and again from 1910 to 1930, statues began popping up all over Lincoln Park. Most of these were gifts from wealthy individuals and families who once made their homes and their fortunes in Lincoln Park. Others were funded by different social groups that wished to create something special and memorable in Lincoln Park. In the middle of the park and at its far southern tip are the park's two museums. One museum tells the story of what the area was like ecologically before people showed up. The other shares the history of the great city in which this neighborhood lives.

On a walk from one museum to the next, there is almost a sense of security knowing that you are being "watched over" by statues of so many important and famous figures...

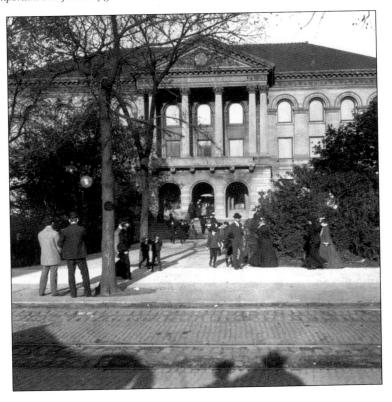

Founded in 1857, The Chicago Academy of Sciences was the first museum in Chicago and thus remains one of Illinois' oldest scientific societies. The building that the museum was housed in until late 1999 was built in 1893. The museum, shown here, stood on Clark Street at the intersection of Clark, Armitage, and Lincoln Park West. In this early photo of the museum, one can see the cable car tracks running down a cobblestone Clark Street. (Photo courtesy of the Chicago Academy of Sciences.)

In 1857, this man, natural history enthusiast Robert Kennicott, was instrumental in the founding of the Chicago Academy of Sciences. Called the "most enthusiastic" of the founding group, 21-year-old Kennicott had a significant background in both taxonomy and zoology. Although raised by a father who did not believe in formal education, Kennicott, who was of "delicate health," learned much about nature from life on a farm called The Grove, which was in present-day Glenview/Northbrook. Kennicott died in 1866 while out during an expedition to Alaska for the Smithsonian. (Photo courtesy of the Chicago Academy of Sciences.)

As the Chicago Academy of Sciences was being set up, a large orb was suspended just beneath the domed ceiling. This is the Atwood Celestial Sphere. Physiographer and astronomer Dr. Wallace W. Atwood, who held positions on the museum board between 1909 and 1918, including acting director, created the sphere. Measuring fifteen feet in diameter, the rotating globe was made of galvanized iron one sixty-fourth of an inch thick. Museum visitors could glimpse a realistic view of Chicago's night sky. Today the sphere resides at Chicago's Adler Planetarium. (Photo courtesy of the Chicago Academy of Sciences.)

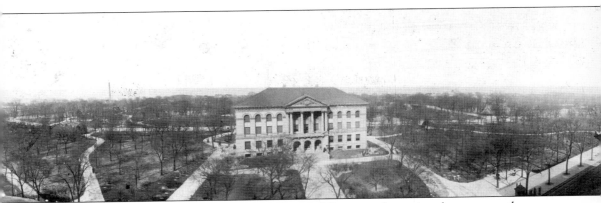

This panoramic view of the Chicago Academy of Sciences shows just how sparse the area around it once was. Today this area is lush with trees and behind the building one would see the Lincoln Park Zoo, its lagoon, and its farm. When the building was being constructed, budget concerns decreased the originally planned size of the museum. Intentions were to add to the building at a later time. The building, which is a memorial to Matthew Laflin, one of its donors, was constructed from Bedford limestone and is built in the "Italian Renaissance" style. (Photo courtesy of the Chicago Academy of Sciences.)

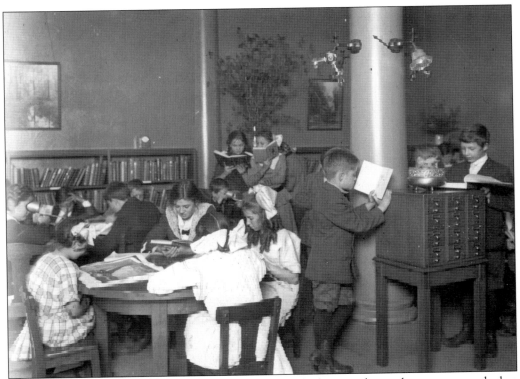

Inside the Chicago Academy of Sciences, children took classes to learn about nature and what their neighborhood was like before people inhabited it. In this late 1800s photo, children read in the museum's library. (Photo courtesy of the Chicago Academy of Sciences.)

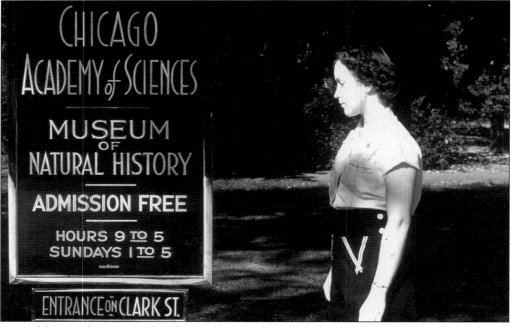

A neighbor reads a sign with information regarding the Chicago Academy of Sciences. Well into the 1970s, admission to the small museum remained free. The Chicago Academy of Sciences was a small museum featuring natural history resources and information on the habitats of plants, animals, and other wildlife as they existed in different time frames. In October 1999, the Chicago Academy of Sciences expanded to become the Peggy Notebaert Nature Museum, and moved to its current home in Lincoln Park on Fullerton Parkway and Cannon Drive. (Photo courtesy of the Chicago Academy of Sciences.)

In the 1970s, workers at the Chicago Academy of Sciences painted shadows in the dioramas to make the scenes appear as realistic as possible. With simulated water, contrasting winter and summer scenes, and minute details such as a predator catching prey, nature scenes like this one looked amazingly real. (Photo courtesy of the Chicago Academy of Sciences.)

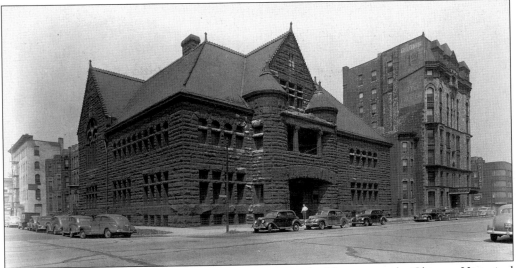

Chicagoans and visitors to Chicago might recognize this building not as the Chicago Historical Society, but rather as the trendy nightclub, Excalibur. Although not in Lincoln Park, it is interesting to see the Chicago Historical Society, c. 1930, as it stood at the corner of Ontario and Dearborn. To the north of the museum one can see the Hotel Raleigh, which rented rooms for $1 per night. The museum vacated this property in 1931 and moved to Lincoln Park, where it remains today. (Photo courtesy of the Chicago Historical Society.)

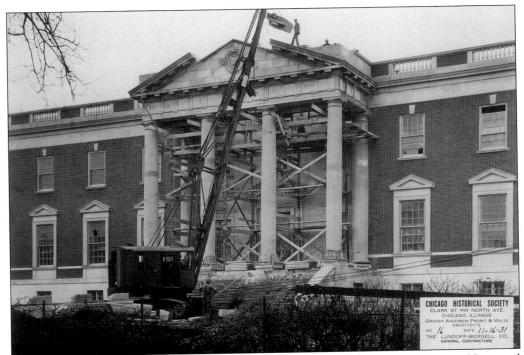

This November 16, 1931 photo shows the construction of the current Chicago Historical Society. Although the front of the museum received an extensive facelift in the early 1970s, this entrance on the east side of the building facing the park looks primarily unchanged today. (Photo by Hedrich-Blessing/Courtesy of the Chicago Historical Society.)

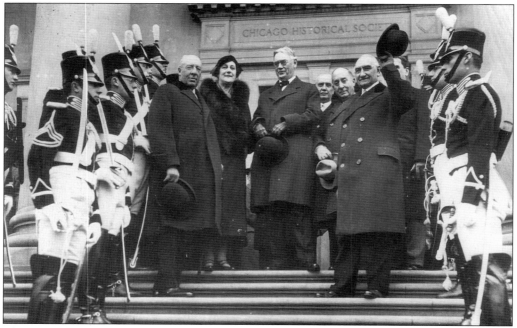

The new Chicago Historical Society is open and ready for visitors. This 1932 photo appeared in the Chicago *Tribune* marking the auspicious occasion. (Photo courtesy of the Chicago Historical Society.)

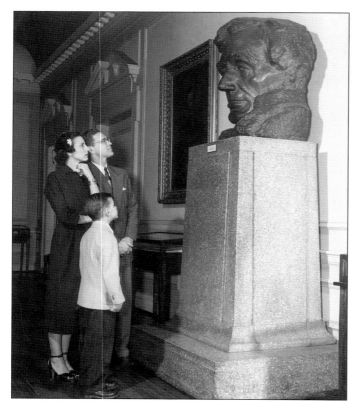

Lincoln Hall and its Abraham Lincoln exhibit at the Chicago Historical Society were favorites of visitors for many years, before being replaced by new, updated exhibits. Here, Mr. and Mrs. Joe Marshall and their son peer into the wise face of the 16th President of the United States. Many years after this 1954 photo was taken, the statue of Lincoln looks somewhat different: its nose is bright and shiny, having been rubbed by so many admiring visitors as they entered Lincoln Hall. (Photo by Ken Schmid Studio/Courtesy of the Chicago Historical Society.)

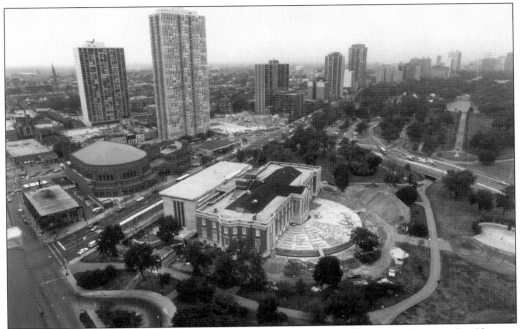

This aerial view of the southernmost tip of the Lincoln Park neighborhood features the Chicago Historical Society, a modest-sized, beautifully maintained museum in Chicago. To the left, across Clark Street, is the rounded Moody Bible Church building. Beside it to the left, at the corner of North Avenue and Clark Street, is the North Federal Savings Bank. Behind the bank and the church is LaSalle Street. To the right one can see the Lincoln Park Lagoon. Construction at the Chicago Historical Society was underway at the time of this photo, c. 1970, during which a four-story addition was added to the façade of the building. Today, beautiful gardens behind the museum are a peaceful place to stroll, read, or just sit on a warm day. Off to the far right, looking somewhat like the number eight is the plaza upon which a large statue of Abraham Lincoln stands. (Photo courtesy of the Chicago Historical Society.)

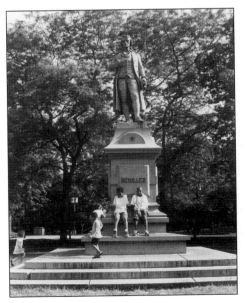

Just north of the Stockton Drive entrance to Lincoln Park Zoo is this statue of Johann Christoph Friedrich von Schiller. The great German national poet was born in 1759 and died in 1805. During his 46 years, Schiller was a surgeon, served in the army, and then he turned to writing. Dedicated on May 8, 1886, his statue was commissioned by a group of German Chicagoans. It was cast using the mold for the original piece, which is displayed in Schiller's birthplace at Marbach, in Würtemberg, Germany. (Photo by Mindy S. Apel.)

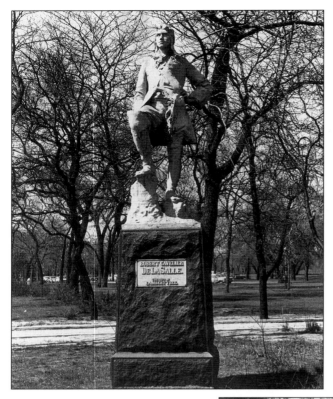

At the intersection of Clark and LaSalle Streets stands a statue of Robert Cavelier de LaSalle, who lived from 1649 to 1687. Count Jacques de la Loring created the statue of LaSalle, a fur trader and explorer who is credited with claiming part of Mississippi for France. The statue was unveiled on October 22, 1887. This May 4, 1961 photo was taken by Tom H. Long. (Photo courtesy of the Chicago Historical Society.)

The Lincoln Monument, by Augustus St. Gaudens, which can be found in the peaceful Lincoln Gardens (donated by Credit Agricole in 1989) behind the Chicago Historical Society, was erected in 1888, or A.D. MDCCCLXXXVIII, as a large inscription on the steps leading up to the statue states. The statue was a posthumous gift of a man named Eli Bates who, when he died in 1881, left $40,000 for the creation of a memorial to Abraham Lincoln. The Sara Lee Corporation restored the statue in 1989. Two large orbs rest at the base of either side of the steps. The one to the west is inscribed with the Gettysburg Address. The one to the east is inscribed with another of Lincoln's speeches on slavery. (Photo courtesy of the Chicago Academy of Sciences.)

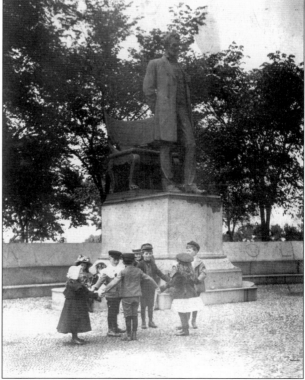

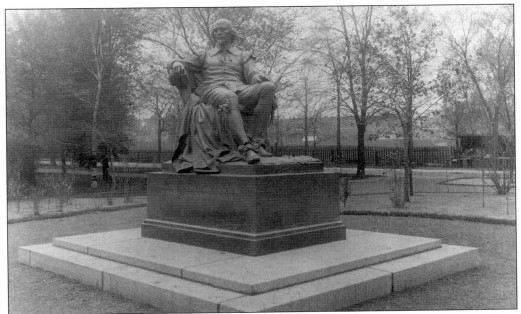

William Shakespeare admires the view. To the east is the Lincoln Park Conservatory (not visible in this photo). Just across the street to the west is the stately Belden-Stratford Hotel. Shakespeare has been sitting here since April 23, 1894, long before the Belden-Stratford and its neighboring buildings along Lincoln Park West were built. (Photo by W.T. Barnum/Courtesy of the Chicago Historical Society.)

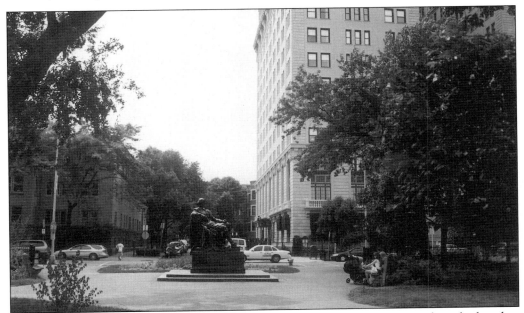

Shakespeare's view has changed considerably. This is how he and his surroundings look today. The monument to the greatest playwright of all time was presented to Lincoln Park by Samuel Johnston and created by William Ordway Partridge after winning a competition to design the statue. This statue of Shakespeare is the first in which the playwright is dressed in clothing that he truly would have worn. (Photo by Mindy S. Apel.)

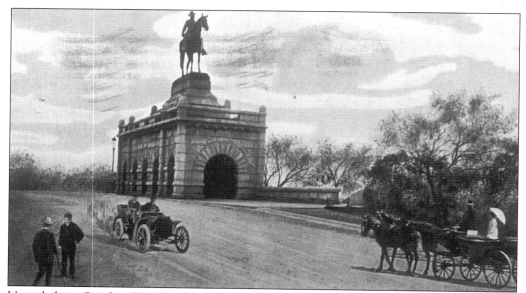

Unveiled on October 7, 1891, the Grant Monument is Lincoln Park's grandest monument. Made of bronze by L.T. Rebisso, the equestrian statue is mounted atop an enormous granite foundation and pedestal. The monument, which in 1899 was called "the largest ever cast in the country," honors General Grant, who died in 1885. This postcard bears an October 19, 1908 postmark and the back of it is noted with the words, "Equestrian figure of colossal proportions mounted on a mammoth base of granite, and overlooking the Lake from LP drive." Pedestrians can still visit this statue en route to North Avenue Beach. (Postcard courtesy of DePaul University Library Special Collections.)

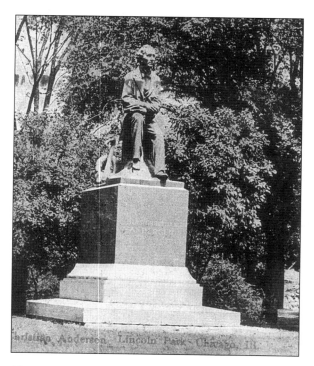

The memorial statue of Hans Christian Anderson, born in 1865, was unveiled on September 26, 1896. Beside the children's fairytale writer is "The Ugly Duckling," the main character of one of Anderson's famous stories. The statue, created and sculpted by John Gelert, was commissioned by the Hans Christian Anderson Memorial Association, a group of former citizens of Denmark. It can be found at 2045 N. Lincoln Park West, just beyond a footbridge that runs under Stockton Drive behind the Lincoln Park Cultural Building. Over the years, children have occasionally scaled the side of this statue in an effort to sit in Hans Christian Anderson's lap, perhaps in hopes of hearing a story. (Photo courtesy of DePaul University Library Special Collections.)

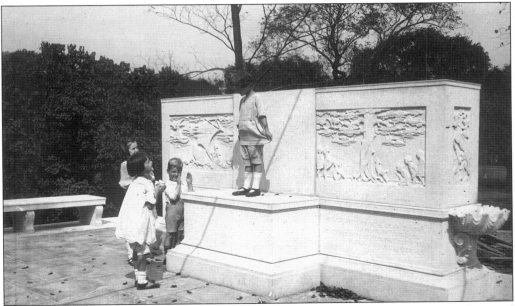

In 1922, a monument was erected in honor of Eugene Field, poet of "Little Boy Blue" and "Wynken, Blynken and Nod" fame. Children stand atop the monument where a statue would soon be erected. (Photo courtesy of the Chicago Historical Society.)

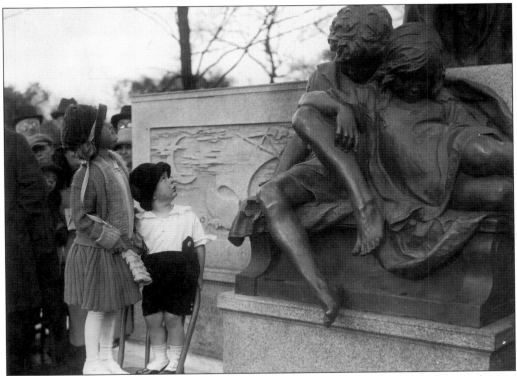

Jean Field Foster and Robert Eugene Field, Eugene Field's grandchildren, stand on a chair to perform the official unveiling of the Eugene Field Monument on October 9, 1922. (Photo courtesy of the Chicago Historical Society.)

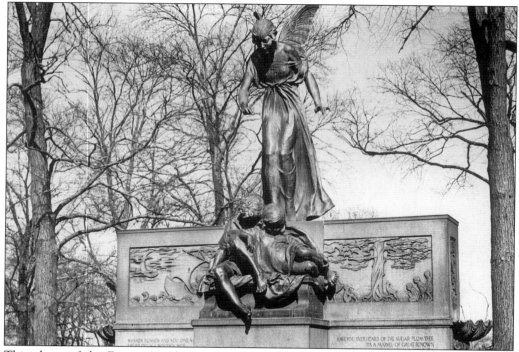

This photo of the Eugene Field Monument was taken in 1952. The sculpture of an angel is called "Dream Lady" and was sculpted by Edward McCartan of New York. The scaloped, flower-like structures protruding from the sides of the monument were, at one time, water fountains. (Photo by Lil & Al Bloom/Courtesy of the Chicago Historical Society.)

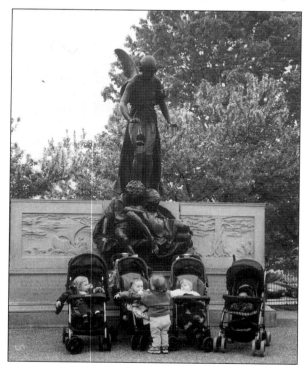

On a cool April day in 2002, baby visitors to Lincoln Park Zoo sat in their strollers at the base of the Eugene Field Monument. From left to right are the young members of a playgroup: Dylan Perpich, Hayden Bonnell, Eliana Prober (standing), Emmy Peek, and Alexandra Bratt. The monument can be found nestled between the zoo's new endangered species carousel and the small mammal house. (Photo by Melanie Ann Apel.)

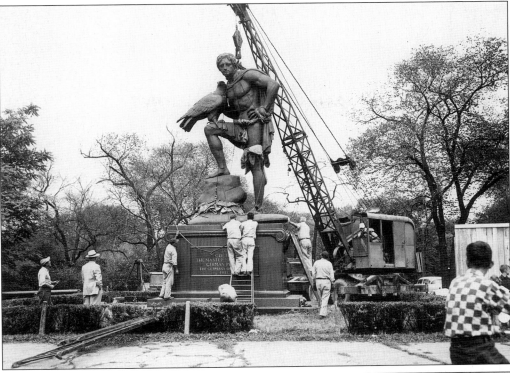

This rather imposing statue watches over the northernmost tip of Lincoln Park, specifically the southeast corner of Diversey and Lake View. Inscribed on the front of the monument are the words, "To Goethe, [pronounced GARE-tuh] The Mastermind of the German People. The Germans of Chicago, 1913." No longer surrounded by bushes, today concrete benches encircle the statue, making it a nice place to stop and rest when walking through park. Also honoring Johann Wolfgang von Goethe, who lived from 1749 to 1832, is a likeness of his face set in the middle of a concrete structure that backs a bench just behind the statue. On either side of the German poet/playwright/novelist/natural philosopher's face is a quote by Faust II in both German and English. In this 1953 photo, workers can be seen repairing damage to the statue caused by lightning. (Photo courtesy of the Chicago Historical Society.)

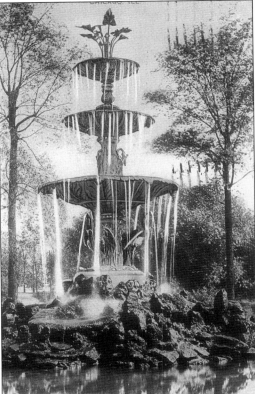

In 1913, this fountain was part of Lincoln Park. (Photo courtesy of DePaul University Library Special Collections.)

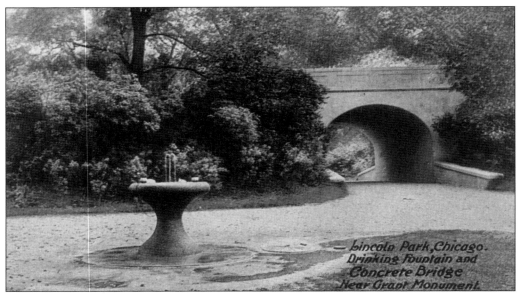

Thirsty visitors to Lincoln Park can still get a sip of cold water from drinking fountains such as this one. This may not seem so extraordinary except for the fact that this postcard shows a concrete bridge and drinking fountain near the Grant Monument in 1913! (Postcard courtesy of DePaul University Library Special Collections.)

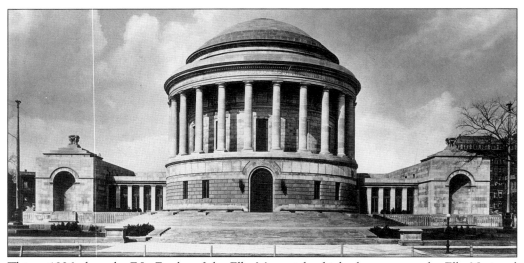

This c. 1926 photo by E.L. Fowler of the Elks Memorial, which also serves as the Elks National Headquarters, stands at the corner of Diversey and Lake View. The Elks Memorial was built in memory of 70,000 Elks members who served in World War I and the 1,000 members who did not return. An architectural contest was held to decide who would design the building. Egerton Swartout of New York City had the winning design. The cornerstone was laid in June of 1924 and the building was completed in 1926. The building was dedicated to American heroes in June of 1926. Rededications in 1946, 1976, and 1994 honored those who served and died for our country in World War II, Korea, Vietnam, and all conflicts since Vietnam. Above the entry, an inscription of patriotism reads: "The Triumphs of Peace Endure, The Triumphs of War Perish." The building is open to the public and well-worth visiting. It is amazing to see such a stunning, palace-like interior, right in Lincoln Park. (Photo courtesy of the Chicago Historical Society.)

Eight

AT HOME
IN LINCOLN PARK

Chicago grew up fast in the early to mid-1800s. Lincoln Park was soon dotted with wooden frame houses, only a few of which survived the Great Chicago Fire of 1871. Following the fire, city building codes required houses to be fireproof. A few wood frame houses that had escaped the flames were moved from the fire district because they did not meet this new code. The park itself was a cemetery, but the rest of the neighborhood thrived as people moved north into Lincoln Park to get away from the stockyards and the railroad. Lincoln Park was soon bursting with grand single family homes. Beautiful brick homes went up all over the neighborhood. World War II caused the neighborhood another dramatic change. Families moved to the suburbs and the Lincoln Park neighborhood deteriorated. In the 1940s, the neighborhood's beautiful homes were divided up and turned into rooming houses, primarily occupied by single men. Today, the move from home to rooming house is still evident in the number of large homes that now house several apartments within. Many others have since been gutted and their original single-family status has been restored.

As it was in the 1800s, to live in Lincoln Park today is a symbol of wealth and achievement, good taste and energy…

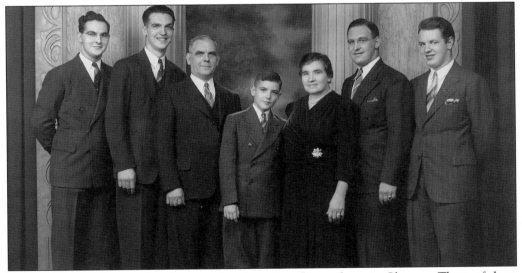

The Fischer family owned and operated at least four flower shops in Chicago. Three of these were in Lincoln Park, but only the location in the 900 block of west Armitage, which the family sold around 1996, remains today. Pictured here are (from left to right) William Jr., Herbert, William Sr., Richard, Anna, Henry, and Walter. Anna and William Sr., who came to America in 1912 and 1911, respectively, and married in 1914, raised their five sons in a close-knit German manner. At one time, ten members, comprising three generations of the Fischer family—Grandma Anna and Grandpa William, their sons Richard and Henry, Henry's wife and five children, Joan, Pauline, Bob, Mark, and Allen—lived in an un-airconditioned, one-bathroom-per-apartment two-flat on W. Dickens. They used the basement of the house to store inventory for their flower shop just half a block west. (Photo courtesy of Joan Fischer Stowell.)

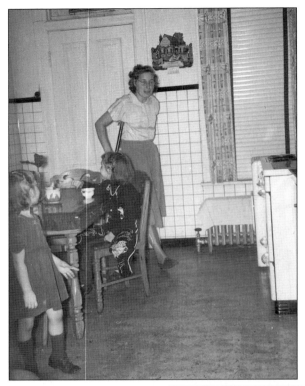

Not having undergone the typical Lincoln Park gutting and remodeling, this two-flat built by a schoolteacher about a decade following the Great Chicago Fire remains markedly unchanged. However, the kitchens on the first and second floor, one of which is pictured here, were said to have been added on, along with a small bedroom just off to the side, sometime after the original erection of the building. The back door, pictured here behind two Fischer children and their mother in 1951, leads to an atypical back yard. Due to flooding and mud in the early years, concrete was poured in the backyard. Immediately behind the yard is an apartment building that was at one time a rooming house for elderly gentlemen. (Photo courtesy of Joan Fischer Stowell.)

Grandma Anna Fischer raised five boys in the three bedroom, one bathroom upstairs apartment in the 300 block of Dickens. Following Anna's death in 1974 the Fischer family sold the building that three generations had called home. This is Anna Fischer and her granddaughter Joan's husband, Joe Stowell, sitting in Anna's second floor dining room in 1968. (Photo courtesy of Joan Fischer Stowell.)

Taken in the mid-1970s, this photo shows a two-flat on Dickens Avenue. Now a landmark home, this house cannot be torn down, as prescribed in a document affixed to the wall just inside the front door. According to legend, this house was built by a schoolteacher about ten years after the Great Chicago Fire of 1871. Records of the house indicate that it was sold in 1898 for $5,000 and later in 1975 for $45,000. Today, property in this area sells for well over half a million dollars. Of interesting note is the fact that in September 1848 the entire block from Clark (then known as Green Bay Road) to Sedgwick, to Armitage (Central Street), to Dickens (Garfield Street) was sold for $268 to a man named Christian Kuhn. Kuhn's family already owned a great deal of land in the area. The building shares a common wall with the building just to its left. This wall split the original 50-foot-wide property in half after an October 1881 agreement.

In 2002, this home in the DePaul area of Lincoln Park was remodeled and featured in a Chicago *Sun-Times* article. Built around 1867, this house was originally situated right in the area decimated by the Great Chicago Fire in 1871. The house was one of a few that survived the fire. Because it was built of wood and therefore not fireproof, regulations immediately following the fire would have required the demolition of the house. The owner of the house, rather than having his house destroyed, moved the house outside the area that was being rebuilt to new fire code standards. (Photo by Mindy S. Apel.)

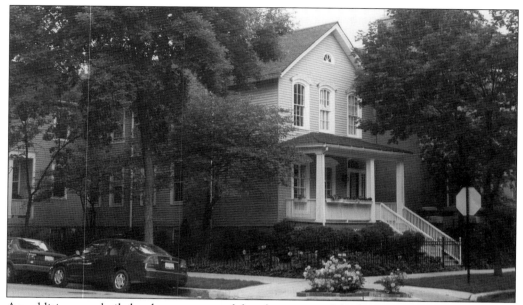

An addition was built by the current, and fourth, owners of the beautiful frame house on the northwest corner of Cleveland and Webster. The house, built sometime between 1830 and 1867, was originally the Swedish consulate. In 1890, Angeline and John Gerten received the house as a wedding gift from Nicholas Gerten, John's father, who was a building contractor. The Gertens raised eight children in the beautiful house. The house narrowly missed being consumed by the Great Chicago Fire in 1871 by merely one block. At the time, the Gerten Family evacuated their home and sought refuge at the DePaul Seminary until the embers nearby had cooled. (Photo by Mindy S. Apel.)

Built in 1872, the year after the Chicago Fire, this house is a classic example of a single-family house turned apartment building. In 1906, the three-story brick home was divided into three separate apartments, with the servants' quarters on the third floor also serving as an apartment. Later, the first floor housed a doctor's office and even later the entire building was home not to a family at all but to a blood bank. Much of the interior was destroyed at this point and the current owner, Mr. Don Green, spent eight years restoring it using what was left of the original woodwork and moldings as a model. The owner hopes to do further restorations and eventually land a spot in the National Landmark Registry. (Photo by Mindy S. Apel.)

Built in 1905 when the street was called Lane Court, this three-story brick home on Orleans Street has always had three apartments within. Long before the street name was changed sometime before approximately 1950, Orleans Street was not even a street. An alley runs from Sedgwick out onto Dickens Avenue just west of Clark Street and it is easy to see how the alley would have extended down what is now Orleans Street. Of interesting note, around the corner on Armitage is the Park West Theater, which was once the Lane Court Movie Theater. (Photo courtesy of Lois Stanley.)

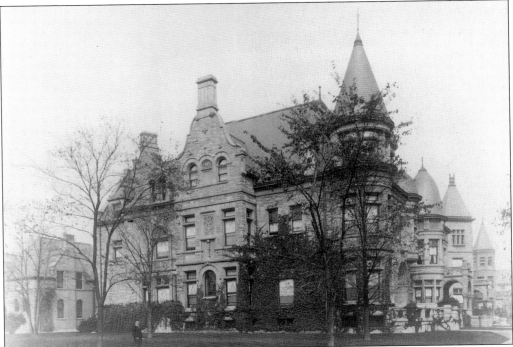

This stately mansion, photographed in 1907, was typical for its era. It stood at the northwest corner of Lakeview and Fullerton. (Photo courtesy of the Chicago Historical Society.)

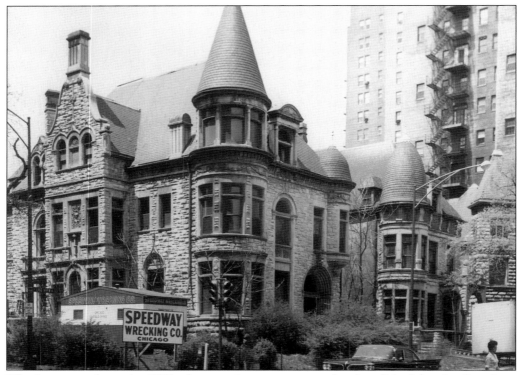

Fifty-four years later, in 1961, the mansion was soon to be demolished by the Speedway Wrecking Company. (Photo by John Spiro/Courtesy of the Chicago Historical Society.)

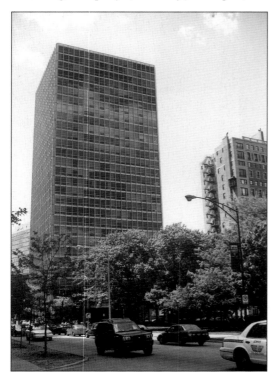

Today this high rise building, featured in the 2001 movie *What Women Want* starring Mel Gibson and Helen Hunt, stands where the mansion in the previous two photos once overlooked the park. Looking closely one can see that the building to the right and behind this high rise—with the fire escape visible—has been standing since before the mansion was demolished. (Photo by Mindy S. Apel.)

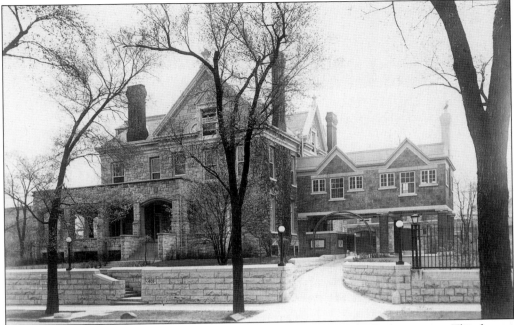

Photographed on April 25, 1915, this is another typical Lincoln Park mansion. This home, which stood at 401 W. Fullerton. was torn down in favor of yet another high-rise apartment building. (Photo courtesy of the Chicago Historical Society.)

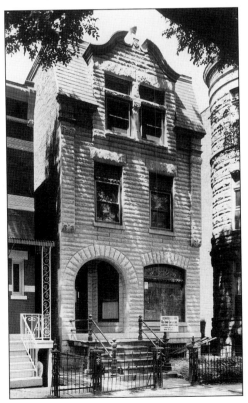

Following a fire in 1965 that nearly gutted this house in the 2200 block of north Fremont, extensive remodeling was done, creating a masterpiece of modern living. (Photo by Donna Lee Johnson/Courtesy of Mary Beth Canfield.)

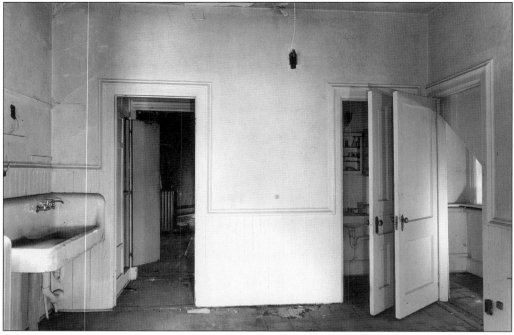

Before remodeling work began, this is how the first floor kitchen of a house on the 2200 block of north Fremont looked. Built for a single family in the 1880s, this house was later divided into three apartments. In the 1960s, after a fire nearly destroyed everything inside the house, remodeling efforts returned the house into a large and beautiful single family home. (Photo by Donna Lee Johnson/Courtesy of Mary Beth Canfield.)

Norman Barry. a television and radio personality and member of Mayor Richard J. Daley's Board of the Department of Urban Renewal, and his wife Marj rented two-thirds of "Crudley Manor," 2141 North Cleveland, from 1955 to 1960. The owners, Ione and Lee Shriver, were reluctant to sell their home to the Barrys, thinking they might wish to occupy the residence themselves one day. In 2001, Marj Barry wrote the history of "Crudley Manor" for the current owners. Most of the houses on the 2100 block of Cleveland were built in the 1890s. After World War II, many of the beautiful houses were converted to rooming houses, a state in which they remained through the 1960s. Known then as a "bad neighborhood," there were two "houses of ill repute" on the block, as well. Perhaps the most interesting tidbit of information about the home in which the Barrys lived is this: At one time, a tunnel was discovered running from the basement of the coach house under the alley to a warehouse on the other side of the alley. The tunnel was used to transfer liquor to the warehouse during the days of prohibition. (Photo by Mindy S. Apel.)

Parts of the 2300 block of Lincoln Avenue, including some beautiful old houses, were demolished in the 1970s in favor of townhouses and condos. (Photo courtesy of Mrs. Norman Barry.)

At the north end of the 2100 block of Cleveland stands this brick, art-deco-style building with diamond-shaped windows. Now a three-apartment building, in the 1920s and 1930s it was a house owned by ballroom dancing siblings Irene and Vernon Castle. Famous in the first decade of the 20th century for changing the world of ballroom dance, the brother-sister dance team was portrayed by Fred Astaire and Ginger Rogers in the 1939 movie *The Story of Vernon and Irene Castle*. (Photo by Mindy S. Apel.)

Inspired by the German architectural style, architects Adolph Cudell and Arthur Hercz designed the Dewes Mansion for Chicago millionaire and brewer Francis J. Dewes. Still standing at 503 W. Wrightwood, the mansion, which was built in 1896, is probably the most elaborate home ever built in Lincoln Park. The home was given Chicago landmark status in June 1974. No longer occupied by the Dewes family or any other, the recently restored turn-of-the-century mansion can be rented for extravagant parties. (Photo by Mindy S. Apel.)

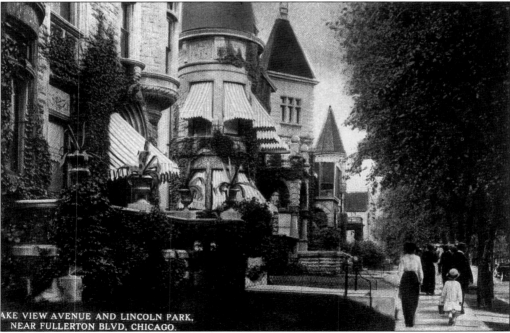

AKE VIEW AVENUE AND LINCOLN PARK, NEAR FULLERTON BLVD, CHICAGO.

Beautiful homes in Lincoln Park have made landmark status due to their longevity as well as their historic value. This is Lake View Avenue, near Fullerton, at a time when Fullerton was referred to as a boulevard. (Postcard courtesy of DePaul University Library Special Collections.)

Nine

LINCOLN PARK'S
LINCOLN PARK

A neighbor-friendly playlot, ice skating on the lagoon, a rugby football club, street fairs, row boats, museums, picnics in the park, hotels to stay in, restaurants of international faire, a zoo, and coffee on almost every street corner. When it comes to fun, Lincoln Park residents know what they are doing. Lincoln Park is a neighborhood swarming with things to do and young people who have taken up residence here because they know just how much fun can be had. Alongside the neighborhood is the park that shares its name. On sunny days the park is visited by neighbors blessed with proximity to such exciting attractions, as well as those who travel by car, bus, or train from the far ends of the city. Once only 60 acres long, Lincoln Park was given expanded boundaries from Diversey to North Avenue in the late 1870s. These boundaries match the Lincoln Park neighborhood's north and south boundaries. However, the park itself now reaches all the way from Ohio Street to Ardmore.

Residents work hard to afford their Lincoln Park homes. But all work and no play is simply no fun at all. Thank goodness for the park called Lincoln Park...

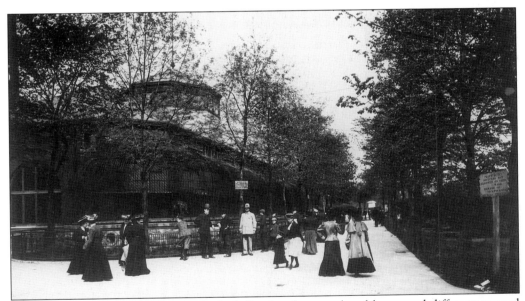

The Large Animal House at Lincoln Park Zoo has been replaced by several different natural habitats in recent ongoing renovations. Lincoln Park Zoo, which opened in 1868 with a gift of two swans from the New York's Central Park Commissioners, was intended for casual entertainment. The zoo received donations of all sorts of rare, interesting animals and attracted visitors for six years before the first actual purchase of an animal was made. On July 1, 1874, the zoo made its first official purchase: two bear cubs, which cost $10. In the early 1900s, zoos were not concerned with the specific well-being of animals so much as they were concerned with showing off as many different types of animals as they could find. (Photo by Barnes-Crosby/Courtesy of the Chicago Historical Society.)

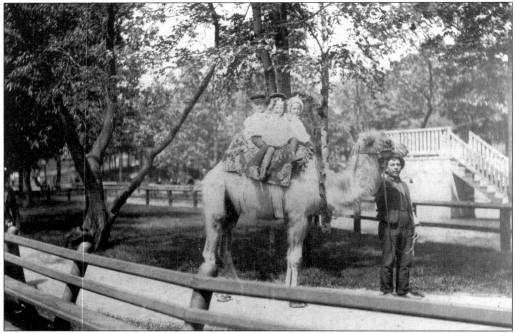

In the middle of the 20th century, small visitors to Lincoln Park Zoo might have been treated to a ride on a pony, the merry-go-round, or even the miniature train that ran around the zoo. But before all of that, in the late 1800s and early 1900s, as one can see, camel rides were a popular amusement at the zoo. (Photo courtesy of the Chicago Academy of Sciences.)

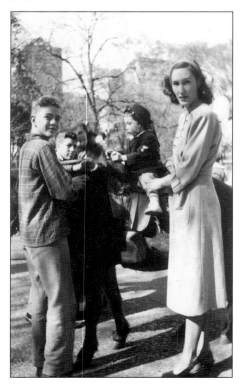

This photo, taken in the late 1940s, shows young Joan Fischer perched apprehensively atop a pony at Lincoln Park Zoo. Holding gently but firmly to little Joan's leg is her aunt, Mary Bracht. The pony ride, along with a miniature railroad train and a merry-go-round, were phased out of the zoo in the early 1970s. Recently, however, updated versions of both the merry-go-round and the train have come back to the zoo. (Photo courtesy of Joan Fischer Stowell.)

Originally referred to as the sea-lion pits, the Seal Grotto at Lincoln Park Zoo was captured on this postcard by E.C. Kropp, Publishers of Milwaukee. The first sea lions came to Lincoln Park Zoo in December 1879. Eighteen sea lions moved in before their first home, the Sea Lion Pool, was completed in 1889. The sea lions escaped from the pool and were next seen looking for food at a nearby Clark Street restaurant. All but one sea lion were returned to the zoo. The 18th sea lion took off for broader spaces and was seen heading into Lake Michigan. The postcard is postmarked July 9, 1905. (Postcard courtesy of Alan Ladd.)

Mailed from Tacoma, Washington on October 30, 1906, this postcard illustrates some of the animals that lived at Lincoln Park Zoo at the time. (Postcard courtesy of DePaul University Library Special Collections.)

At one time, visitors to Lincoln Park could walk beside this lovely Lily Pond. The body of water was originally a natural pond or ravine. In 1889, the pond was turned into this Lily Pond. Artificial heating devices were used to promote the growth of the exotic and beautiful water lilies, some of which were grown from Egyptian seeds. Fifty years after it opened, Alfred Caldwell cashed in his life insurance policy to fund the redesigning of the pond to replicate a prairie style. The pond came to be known as the Zoo Rookery. Although at first Caldwell traveled to Wisconsin to personally pick out wildflowers for the Rookery, by the end of the century the pond had fallen into disrepair and was closed for quite some time. On May 18, 2002, the new Alfred Caldwell Lily Pool was opened. (Postcard courtesy of Alan Ladd.)

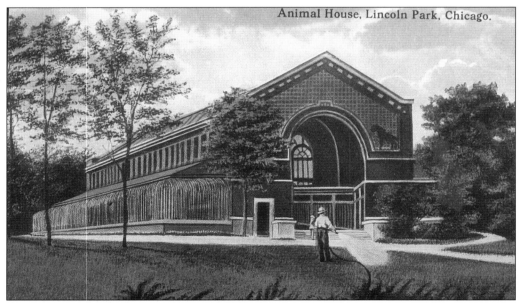

This old postcard shows a sketch of Lincoln Park Zoo's Animal House. It seems that at one time all of the zoo's animals may have inhabited this one house. (Postcard courtesy of DePaul University Library Special Collections.)

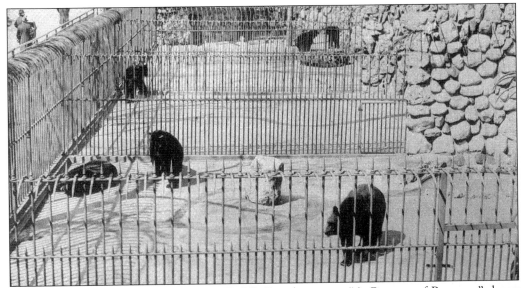

This postcard from the 1933 Chicago World's Fair, known as "A Century of Progress," shows the habitat—or more accurately, the cages—in which bears once lived at Lincoln Park Zoo. At the time, Lincoln Park Zoo was the only zoo in the area and the postcard noted this with the caption, "Chicago's Zoo is located in Lincoln Park." Three years prior to the World's Fair, Lincoln Park Zoo moved its fish collection, which had opened in 1923, to the brand new John G. Shedd Aquarium on Chicago's south side. With a bit of modification, the zoo's aquarium became its Reptile House. (Postcard courtesy of Samantha Gleisten.)

In 1968, two-year-old Stephanie Stanley and her four-year-old brother Dean sat atop this stuffed bear, which guarded the Lion House in Lincoln Park Zoo. Twenty-four years earlier, in 1944, Marlin Perkins, a former curator at the Buffalo Zoo, became Lincoln Park Zoo's fourth director. In 1949, Perkins began hosting a weekly, live television series called "Zoo Parade," which, until 1957, brought Lincoln Park Zoo into homes across America. Later, Marlin Perkins would gain fame as the host of the television series "Wild Kingdom." (Photo courtesy of Lois Stanley.)

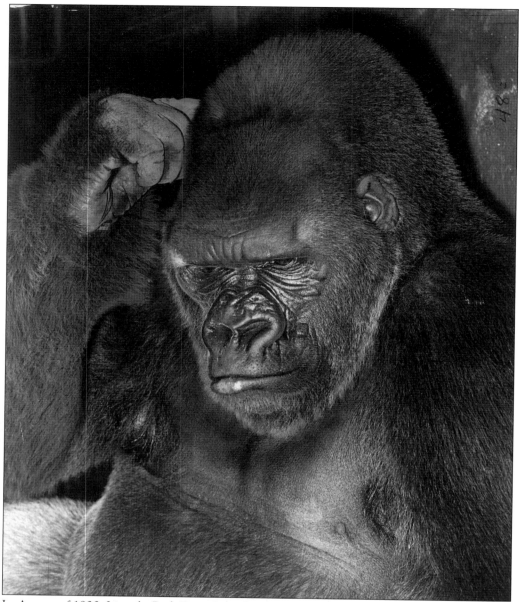

In August of 1930, Lincoln Park Zoo adopted a two-year-old, 38-pound orphan Gorilla named Bushman. Bushman, who reached a height of 6 feet 2 inches and a weight of more than 550 pounds, lived for 21 years at Lincoln Park Zoo and was its most famous gorilla. Pictured here in 1947, Bushman was the first lowland gorilla kept in a zoo west of the Potomac River. As the zoo's patriarch gorilla, Bushman headed up the nation's first program for breeding lowland gorillas in captivity. Bushman was known for his strength and his sense of humor, and the nation's zoo directors voted him the "most outstanding animal in any zoo in the world." When, in June of 1950, Bushman was ill and his death seemed imminent, an estimated 120,000 of his fans came to visit him in just one day. Bushman rallied for a few months after this, but died of heart failure on New Year's Day 1951. The news of his death made headlines. Mourners filed past his empty cage, now on display at Lincoln Park Zoo, for weeks. Bushman is now on display at Chicago's Field Museum. (Photo courtesy of the Chicago Historical Society.)

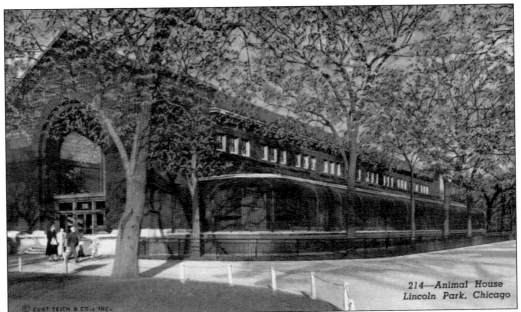

The back of this postcard of Lincoln Park Zoo's Lion House is inscribed with the date 3/17/51. A sign of the times, the postcard is also printed with the following introduction to the zoo: "The Lion House has always been a major attraction for both juvenile and adult visitors to the Lincoln Park Zoo. Here can be seen almost all species of feline beasts, many of which were captured by well-known game hunters."

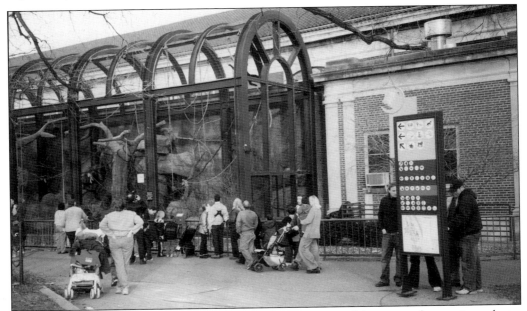

This January 2002 photo shows approximately the same area of the zoo as the previous photo. Things have changed a great deal in the past 134 years, but one thing remains the same: Lincoln Park Zoo continues to attract visitors. The zoo hosts more than three million visitors annually. Today, Lincoln Park Zoo works hard to provide each animal with as close a replication to its natural environment as possible. (Photo by Mindy S. Apel.)

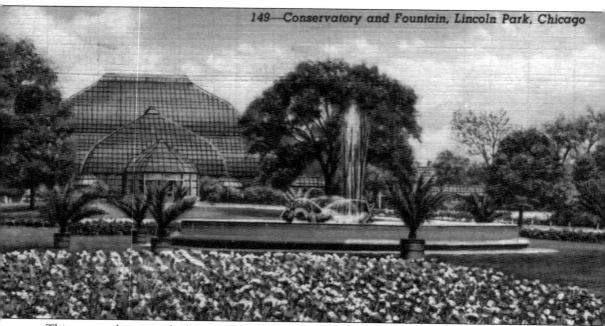

This postcard, postmarked December 8, 1942, shows the Formal Garden and Conservatory in Lincoln Park. "Tulip time in Lincoln Park" is the title of the postcard and its caption reads, "A park of great natural beauty, extending along the shores of Lake Michigan and covering over 600 acres." (Postcard courtesy of Alan Ladd.)

The French-style Formal Gardens in Lincoln Park, between the zoo and the conservatory, takes its visitors out of the hustle and bustle of the busy neighborhood and into a peaceful, fragrant world. One of Chicago's oldest gardens, the Formal Gardens were first designed and planted in the late 1870s surrounding the park's first greenhouse, built around the same time. In the spring and summer, children love to play near and in the beautiful fountain nearby. The fountain, known as the Bates Fountain because it was a gift from Eli Bates, surrounds a statue called "Storks at Play," which was created in 1887 by Augustus St. Gaudens and his assistant, Frederick William MacMonnies. (Photo courtesy of DePaul University Library Special Collections.)

The Conservatory can be seen in the background of this early 1950s photo of Lincoln Park resident Joan Fischer. The daughter and granddaughter of florists, Joan might have looked a bit more pleased to be sitting among the beautiful flower display! (Photo courtesy of Joan Fischer Stowell.)

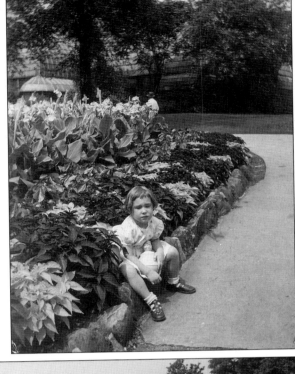

Although the gardens are far more beautiful when the flowers are fully in bloom, this is what the Lincoln Park Formal Gardens look like today. The original greenhouse, which stood in the midst of the garden, was razed in 1890. Built to replace it was the Victorian conservatory that remains at the north end of the garden. Today it is not unusual to see a wedding party posing for formal portraits among the blooming foliage of the Formal Garden. Just across the street to the west of the Formal Garden, on Stockton Drive between Fullerton and Webster, is a smaller, old-fashioned garden known as Grandmother's Garden. (Photo by Melanie Ann Apel.)

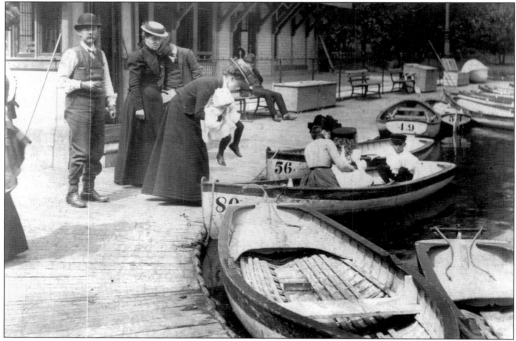

One of the park's main attractions for more than 100 years has been its lagoon. From rowing in the summer to ice skating in the winter, this spot has given Lincoln Park residents a source of inexpensive recreation since the late 1800s. In this photo, a family sets out for a row on the water. (Photo courtesy of the Chicago Academy of Sciences.)

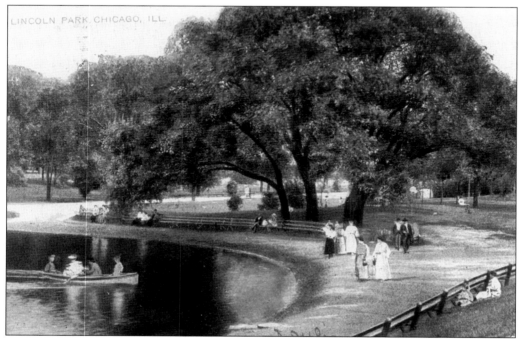

This 1908 postcard of Lincoln Park shows boaters enjoying a warm day in the park. (Photo courtesy of DePaul University Library Special Collections.)

In 1954, Lincoln Park resident Don Dimmit brought his camera to a spot he always found interesting. Looking over the metal bridge onto the rowers on the lagoon, he shot this image and the following photo as well. The rowboats are long gone, as is the metal bridge. Today paddleboats fill the lagoon in summer and boaters are required to wear life jackets. (Photo by Don Dimmitt.)

The Lincoln Park lagoon's rowboats were hard to maneuver. Anyone could rent a boat and take to the water, no experience necessary. As these 1954 photos tell great stories, one can see that the lagoon was a nice place to meet people, have a chat, relax, and maybe even flirt with other boaters. (Photo by Don Dimmitt.)

For many years Lincoln Park residents have found recreation in the park during winter months as well as in the summer. The lagoon between the Lincoln Park Zoo and its Farm-In-The-Zoo often freezes over, providing skaters with a lovely outdoor skating rink. When toes and noses reach freezing point, ruddy skaters retreat inside for a warm cup of cocoa. (Photo courtesy of DePaul University Library Special Collections.)

The John Hancock building on downtown Chicago's Michigan Avenue is clearly visible in this beautiful view of Lincoln Park looking south from the lagoon. Once filled with rowboats, paddleboats became the lagoon's summer attraction in the 1980s. (Photo courtesy of Apel Family Collection.)

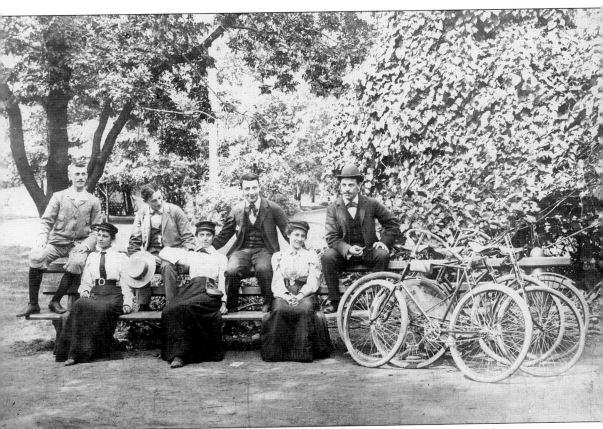

Bicyclists stop to rest in the shade at the picnic grounds of Lincoln Park on an afternoon in 1819. (Photo courtesy of the Chicago Historical Society.)

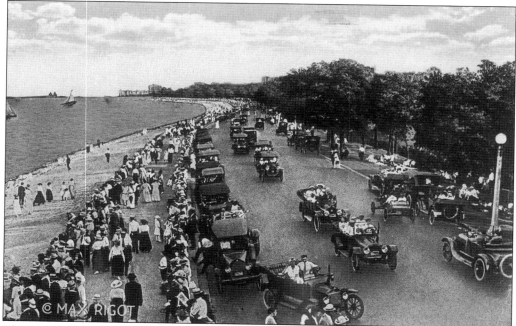

This postcard from the early 20th century depicts a typical Sunday afternoon along the shores of Lake Michigan. Today, the Fullerton Avenue Beach and the North Avenue Beach are still popular spots for Lincoln Park residents during the summer months. However, where there once were cars, bicycles and rollerbladers now dominate. (Postcard courtesy of DePaul University Library Special Collections.)

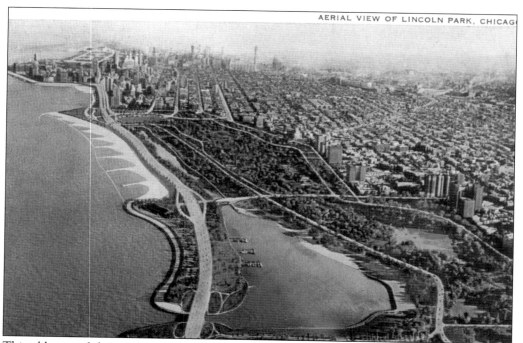

This old turn-of-the-century postcard shows an aerial view of Lincoln Park. (Postcard courtesy of DePaul University Library Special Collections.)

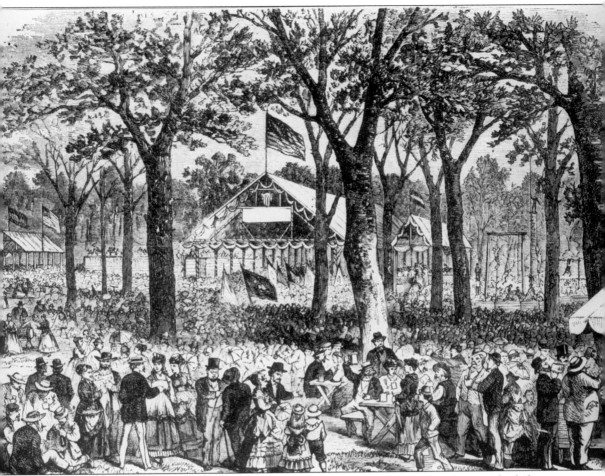

Wright's Grove was a popular German picnic grove and beer garden. It stretched from Wrightwood Avenue to Diversey Parkway along Clark Street, which in the 1880s was called Green Bay Road. This sketch from 1868 shows picnickers enjoying the German Saengerfest, a popular music festival of the era. Wright's Grove was originally an Army camp during the Civil War, an assembly point for the 132nd and 134th Illinois infantry regiments. Today, this stretch of Clark Street is home to shops, restaurants, the post office, apartments, and the neighborhood's oldest McDonald's. (Photo courtesy of the Chicago Historical Society.)

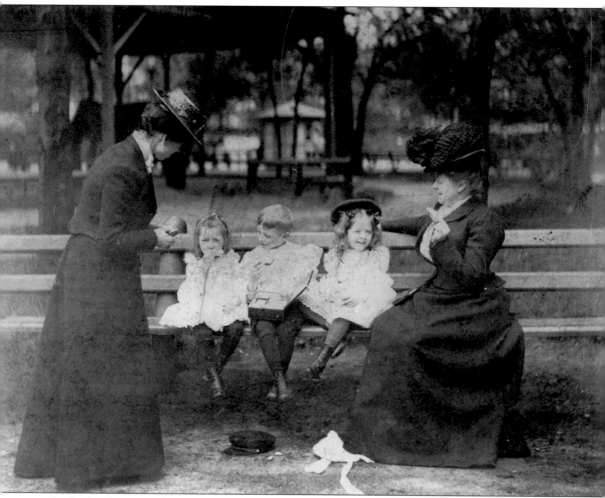

In the late 1800s or early 1900s, three small children and their mothers enjoy a picnic lunch in Lincoln Park Zoo. Around this time, 1899 to be exact, the "Red-Roofed Café" opened in the middle of the zoo to provide visitors with a place to purchase a snack or something to drink. The café, which is located right across from the Sea Lion Pool, later changed its name to the Landmark Café. (Photo courtesy of the Chicago Academy of Sciences.)

The playground in Lincoln Park at Dickens, just across the street from the Lincoln Park Zoo, has attracted neighborhood children for years. In nice weather, children from all over the city flock to this playground. When this photo of Joan Fischer, her little sister Pauline, brother Robert, and their mother was taken in the 1950s, the playground was a typical concrete playlot complete with slides, swings, wooden teeter-totters, a merry-go-round, monkey bars, and a sandbox. (Photo courtesy of Joan Fischer Stowell.)

In 1993, the playground was given a complete makeover, as this photo shows, and was renamed the Cummings Playground in memory of golf pro Dexter Cummings and his sister Edith Cummings Munson, a 1920s golf celebrity and daughter of Chicago socialites. (Photo by Mindy S. Apel.)

The Old Town Art Fair has been a favorite street fair of Lincoln Park residents since 1950. In 1951, photographer Lee Balterman captured this charming image of two little girls doing some serious people watching. The Old Town Art Fair is held the second weekend in June at the 1800 blocks of Lincoln Park West and Orleans, and on Menomenee, Wisconsin, and North Park Avenues. Originally this was a small art fair held in alleys, yards, and against fences. Today the Old Town Art Fair is one of Lincoln Park's summer musts. (Photo courtesy of the Chicago Historical Society.)

Patrons stroll about the Old Town Art Fair in the 1950s. Each year the Old Town Art Fair attacts several thousand patrons who come to see the works of more than 250 artists. Photos, prints, paintings, sculptures, fiber work, and jewelry are the focus of this annual two-day event. Many come for the art, while many others come for the food and drink as well as the people watching. (Photo courtesy of the Chicago Historical Society.)

Neighbors step through the coach house behind 2141 N. Cleveland during the Mid-North Association Garden Walk sometime between 1955 and 1960. (Photo courtesy of Mrs. Norman Barry.)

The Biograph Theater, located at 2433 North Lincoln Avenue just north of Fullerton, showed first run movies on its four screens until it closed in 2001. One of Chicago's oldest remaining movie houses, the Biograph was designed by Samuel N. Cowen (an architect known for his downtown office building designs), and opened its doors for business in late September 1914. The most famous event to take place at the theatre was the 1934 shooting of John Dillinger. The theater remains famous for this nationally-spotlighted real-life drama. Perhaps because of the Dillinger shooting, the Biograph Theater is believed, by some, to be haunted. The marquee, which was erected in 1933, remains relatively unchanged to this day. However, a vertical sign was removed in the 1950s. Until the 1970s, the theater had just one screen. The Biograph Theater is also well known for its four-year sold-out run of the Rocky Horror Picture Show in the late 1970s and early 1980s. When Plitt Theaters bought the Biograph, Rocky Horror came to an end. (Photo by Mindy S. Apel.)

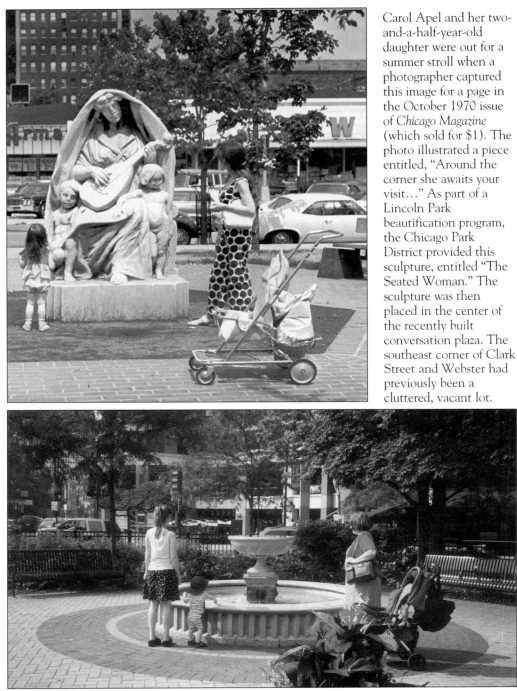

Carol Apel and her two-and-a-half-year-old daughter were out for a summer stroll when a photographer captured this image for a page in the October 1970 issue of *Chicago Magazine* (which sold for $1). The photo illustrated a piece entitled, "Around the corner she awaits your visit…" As part of a Lincoln Park beautification program, the Chicago Park District provided this sculpture, entitled "The Seated Woman." The sculpture was then placed in the center of the recently built conversation plaza. The southeast corner of Clark Street and Webster had previously been a cluttered, vacant lot.

"The Seated Woman" no longer sits in this corner, seen in the previous photo. In recent years, due to disrepair, a fountain replaced her. In just over 30 years, even the view from the corner has changed. In the background, instead of the Armanetti Liquor store and the Jewel, neighbors now shop at Tower Records and the Express and Structure clothing stores. Carol Apel, still a Lincoln Park resident, returned to the corner with her daughter and one-year-old grandson Hayden to pose again for a 2002 version of the 1970 photo. (Photo by Mindy S. Apel.)

In the early 1990s, Lois Stanley's annual Christmas caroling party found shelter from the cold weather at the Lincoln Park Senior Center at 2140 N. Clark. Carolers and Lincoln Park neighbors pictured from left to right, are as follows: Darwin R. Apel (who lead the carolers in song), Joanne Moraitis, Lois Stanley, Marty Niedelson, Virg Kaspar, Bonnie Pobgee, Sue Frankenfield, Pat Meade, Rich Pobgee, Wade Buckles, Ann Gibson, and Bryan Niedelson. Mrs. Stanley has held her Christmas Caroling Party for more than 25 years, treating neighbors, as well as patients in the old Augustana Hospital, to joyful Christmas caroling. (Photo courtesy of the Apel Family Collection.)

Known as the "Killer B's" in the late 1980s, Lincoln Park Rugby Football Club Team B tries to strip the ball from Kellogg in a loose ruck during a "mud game" at the old Diversey pitch. The Lincoln Park Rugby Football Club claims to be one of the oldest of its kind in the Midwest. Founded in 1968 by Dan Fohrman, the LPRFC has traveled to Europe for the sport of it. Always accepting new members, LPRFC does not require its players to have former experience with the sport. (Photo courtesy of John Albergo.)

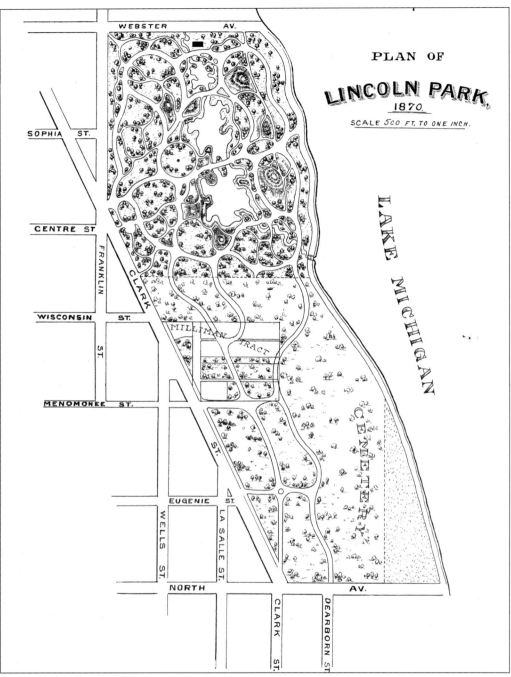

From the fragile, yellowed pages of a beautiful old book entitled, *Lincoln Park 1899*, compiled by I.J. Bryan and published in 1899 by the commissioners of Chicago, comes this 1870 map of Lincoln Park. Showing the section of the park that at the time ran only from Webster on the north to North Avenue on the south, this map notes the old cemetery as well as some streets whose names remain the same today. Center Street, as noted earlier, is now Armitage and Sophia Street appears to have been the name of Dickens Avenue even before it was called Garfield. (Map Courtesy Dr. Paul Heltne/Chicago Academy of Sciences.)